Flush! Modern Toilet Design

Ingrid Wenz-Gahler

Flush! Modern Toilet Design

Birkhäuser – Publishers for Architecture

Basel · Boston · Berlin

Translation: Robin Benson, Adam Blauhut

Graphic design: Christina Hackenschuh, www.hackenschuh.com

Front cover: Club XL in Chelsea, N.Y., Design: Desgrippes Gobé Group, N.Y. (photo: John Horner)

This book is also available in a German language edition (ISBN 3-7643-7181-1).

A CIP catalogue record for this book is available from the Library of Congress, Washington D.C., USA.

Bibliographic information published by Die Deutsche Bibliothek

Die Deutsche Bibliothek lists this publication in the Deutsche Nationalbibliografie; detailed bibliographic data is

available in the internet at http://dnb.ddb.de.

© 2005 Birkhäuser – Publishers for Architecture,

P.O. Box 133, CH-4010 Basel, Switzerland.

Part of Springer Science+Business Media

Printed on acid-free paper produced from chlorine-free pulp. TCF ∞

Printed in Italy

ISBN 3-7643-7180-3

9 8 7 6 5 4 3 2 1 http://www.birkhauser.ch

Table of Contents

Worlds of Experience

Public Toilets

Designing Toilets: An Introduction

Toilets and design?

Everyone is familiar with them – everyone uses them. Toilets and the rooms containing them are such self-evident parts of our daily lives that we seem justified in asking: what do they have to do with design? Does 'design', in this context, refer to unusual toilet seats, to the fashionable accessories in home-living and bathroom magazines, or maybe even to wellness resorts? We all associate toilets with very distinct experiences, the most positive of which can remain in memory for a surprisingly long time. About twenty years ago, I marvelled at public toilets in Canada and the USA that were not only clean, but spacious and inviting as well. In Parisian restaurants I discovered lavatories with wraparound mirrors and indirect lighting. The Barcelona night clubs designed by Alfredo Arribas in the 1980s owe much of their fame to their lavatories. On Lanzarote, I was inspired by the sensitive architecture of the Spanish architect César Manrique, whose buildings, offering wonderful sea and island vistas, are worth visiting for their toilets alone. I have also been impressed by the descriptions of the Japanese author Tanizaki Jun'Ichiro, who pays tribute to traditional Japanese toilet culture in his small volume *In Praise of Shadows*: 'The parlor may have its charms, but the Japanese toilet truly is a place of spiritual repose (...) in a grove fragrant with leaves and moss (...) and quiet so complete one can hear the hum of a mosquito.' For decades, toilets were seen in Europe as insignificant ancillary rooms, where function and hygiene were all that mattered. They were, for the most part, no-frills, geometrically patterned places. It was only with the economic boom of the 1980s that buildings were constructed in our cities that reflected new ideas about corporate image and quality, thereby making architecture and design important commercial factors. At the same time, more and more people began to realise that aesthetically designed products and spaces not only had a specific form, but conveyed content and emotion as well. They created added value inasmuch as they allowed companies to distinguish themselves from rivals that were offering similar products and services. Restaurant proprietors quickly

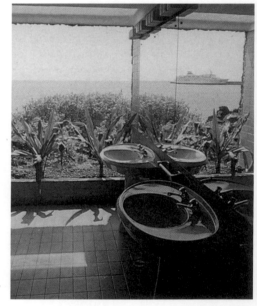

A room with a view – lavatory on Lanzarote, Spain

*Wagamama Noddle Bar in London
(Design: Corporate Edge, London)*

recognised the potential for both themselves and their images and began competing for customers by offering them specially designed lavatories. Seen from this perspective, toilets constitute an important antithesis to food and drink and influence the opinions customers form of a restaurant and its cuisine. It is no coincidence that in the restaurant business many believe that the quality of an establishment is closely linked to that of its toilets. In many cases, toilets are its 'centrepiece'. Particularly in trendy restaurants and in the club and bar scene, they must not only be clean but entertaining too, offering users a veritable design experience. It is not uncommon for proprietors to invest up to ten percent of their total budget in toilets. Society's growing mobility has also brought about changes in our toilet culture: forced to do without a home, we must come to grips with the permanent conflict between always being on the move and always wanting to feel at home. 'At home on the road' is an apt slogan not only for the hotel industry, but also for buildings and facilities used for leisure activities and transportation. Whether at train stations or airports, on trains or ships, at exhibitions or in museums, spacious and pleasantly designed public toilets are welcome retreats from the hustle and bustle of modern life. They reflect the changed needs of our society too.

From ancient toilets to modern hygiene centres

People have been answering the call of nature since the dawn of time, in ways specific to the eras and cultures in which they lived. No sooner did our ancestors have a home than they looked for a place to dispose of their bodily wastes. You may think that the water closet is a modern invention, but it already existed, in a different form, in the advanced civilisations of antiquity. As early as 2,500 BC, people sat on stone benches containing holes, with water running underneath. In Greece, Egypt, India, South America and China – wherever water was available – we find toilets that were connected to underground drainage systems.

Stone bench from ancient Egypt

In past cultures – when community played a greater role in daily life – toilet facilities were located not only at the seats of power, but also near temples and monasteries. The most famous of these were the Romans' public latrines, which still can be viewed today. Frequently laid out in a semicircle, such toilets featured a variety of furnishings. The finest had marble seats, marble statues, a colourful mosaic floor and wall frescoes. Water

gurgled from small fountains, whilst plants and windows under the ceiling improved air quality. Can any of our contemporary public toilets compete with such opulence?

Taking a bath and visiting the toilet remained public affairs for centuries. For kings, princes and even generals, latrines were a worthy 'throne' from which to grant audiences. Lord Portland, an ambassador to the court of Louis XIV, was greatly honoured to be received in this manner. Yet even if bowel movements – in theory and practice – remained a public concern in the Middle Ages, there were no public toilets. Apart from latrines, privies and heart-style toilets (with a small heart cut into the door), people used chamber pots and close stools in their private homes, mostly with manual disposal systems that could not hold a candle to the water drainage systems of antiquity. In many countries, there were repeated campaigns and edicts to erect public toilets, but open fields and streets were much more popular places, even though they were also used by children and animals. This, of course, meant that diseases and epidemics spread rapidly – a hygienic nightmare that was worsened by the Church's washing and bathing bans, as well as by taboos related to the human genitals. Real change only came with the Enlightenment and the French Revolution, whose champions demanded reforms for this sphere of life too. With the development of the English water closet by John Harrington in 1589 and the 'S-trap' by Alexander Cummings in 1775, the most important components of the modern flush toilet were now available, but it took some time for all private and (most importantly) public lavatories to be equipped with flush toilets. In the cities of Central Europe, an extensive water supply and sewage system had to be developed before water closets could be installed. The Great Exhibition of 1851 and the construction of the Crystal Palace accelerated the spread of sanitary facilities, since the 800,000 visitors were highly dependent on them.

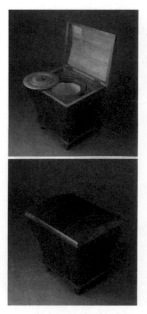

Biedermeier chamber closet
(ca. 1840)

In the ensuing decades, 'designer' toilets and washing areas were to be found primarily in luxury hotels. All other public buildings (shops, museums, swimming pools, schools, universities, office buildings) offered only humble facilities, if any at all. These remained non-places that were better off forgotten.

Only in the mid-1980s did architectural journals and tour guides begin reporting on Mediterranean cafés and bars whose out-of-the-ordinary toilets were just as sophisticated in design as the bars themselves. The joie de vivre and newly discovered creative

pleasure were reflected in washing areas and lavatories with broad mirrored walls, free-standing chromed washstands, dramatic lighting and babbling mirrored urinal walls.

Some ten years later, transport companies such as the Deutsche Bahn railway realised that it was high time to give their customers more in the way of service culture at its stations. Deutsche Bahn held a design competition for lavatories and washing areas in an effort to satisfy its passengers' new hygienic, security and comfort needs. A 1996 Deutsche Bahn brochure presenting both the 'new WC generation' and the company's new concept stated: ' "Travel freshness" wants to make the toilet a place where you will feel at home . . . with all the standards of hygiene culture.' Two years later, the Swiss company McClean began marketing its own hygiene centre for railway stations. Featuring a light and friendly atmosphere, it included washing, showering and nappy-changing areas, as well as toilet cubicles and a small hygiene shop that doubled as a reception desk. When the first hygiene centre was opened at the Basle SBB railway station in 1998, the Basle-based interior designer Annette Stahl explained: 'The lavatory is the centrepiece of railway stations and restaurants – it is a place where one goes both to relieve and to groom oneself, a place where one finds peace and relaxation. Our visitors are our guests, and they deserve our courtesy and attention.'

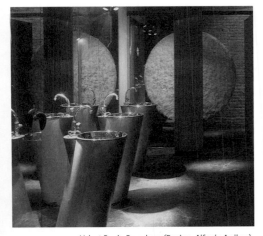

Velvet Bar in Barcelona (Design: Alfredo Arribas)

'Toilet' – a definition

A toilet is a place that each of us visits several times a day. Based on an average of eight minutes a day, we will all spend roughly 3,650 hours or 150 days in the toilet in the course of our lives. These estimates are twice as high for the Japanese. Reason enough take a closer look at this matter!

The German word *Abort* (outhouse, toilet), which has fallen into disuse, refers to an outdoor convenience that used to be common in many countries. The German words *Klo* and *Klosett* are closely related to the English 'water closet', in which water is kept in a cabinet. As in many other languages, *Toilette* (toilet) is generally the most polite term to describe the room used for the disposal of bodily wastes. *Toilette* is a diminutive form of the French *toile* (cloth), and describes not only a bureau or vanity for cosmetics and washing utensils, but also the act of dressing or getting ready. It thus has connotations of putting on a kind of artistic disguise. As this and other terms reveal, the room evokes

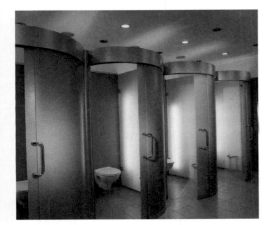

'Travel Freshness' by Deutsche Bahn

associations that go far beyond the act of emptying of one's bowels. In a *cabinet d'aisance*, for instance, the emphasis is on relief; a *retirade*, on the other hand, is a place of retreat and seclusion. In German-speaking regions *Das stille Örtchen* (quiet place) is also a room for relaxing and relieving oneself – it signifies a narrow, intimate space.

The toilet reveals more about our relationship to our bodies than any other room in the house. The modern obsession with disinfecting and perfuming this room and our bodies demonstrates just how alienated we have become from ourselves. At the same time, modern lavatories in semi-public areas not only offer an opportunity for retreat and seclusion, but also for self-presentation.

Caught between function and technology

In our cultures, sexuality and eroticism, as well as disease, death and bodily excretions, are taboo subjects for architects and designers. As a result, the toilet always plays a subordinate role as a functional space that is addressed during planning, only to be discreetly hidden within the building later on. Even so, its status has improved radically over the past few decades, as a look at Ernst Neufert's *Bauentwurfslehre [Architect's Data]* reveals (a standard work on architectural theory for planners and architects). The 1968 edition of *Bauentwurfslehre* only describes the difference between a squat toilet and a toilet on which one sits. It provides information on the numbers of toilets necessary for schools, hotels and dormitories: one toilet for six to ten students; two urinals/one toilet for 80 men, and three toilets for 100 women in the reception area of a hotel. The 2002 edition has been extensively revised: the less common German word for toilet, *Abort*, has been replaced by *WC-Anlage*, or toilet facility. Five pages are devoted to diverse solutions for individually designed or prefabricated bathing and sanitary units with integrated toilets. The discussion of restaurants and hotels includes floor plan suggestions, and there are proposed plans for restaurants, offices and workplaces (though these hardly differ). Under the heading 'industrial architecture', the book presents extensive plans and socio-psychological observations on toilet design: 'The functional and appealing design of sanitary units and social spaces for the creation of a good company atmosphere. This includes toilets, changing rooms, saunas, shower-baths and bathrooms with tubs.'

For decades the American researcher and architecture professor Alexander Kira studied human needs and the consequences for design. In the 1960s he published *The Bathroom*, which contained a variety of studies on human anatomy and physiology, as well as recommendations for the design of baths, showers and even toilets. His specifications for the design of sanitary units are extremely detailed and show the many ways in which both socio-cultural and behavioural-psychological factors influence their use. However, Kira's insights have largely been ignored in the development of toilet seats and urinals over the last few years, which has generally confined itself to producing variations in surfaces and shapes.

In contrast, Geberit, one of the largest manufacturers of sanitary technology, offers some highly useful tips on public toilet design: for a pleasant atmosphere, sanitary units should be spacious and clearly laid out, with a separate washing area and partitioned toilet cubicles to provide privacy. Dark corners should be avoided. Colourful design, music and fragrances will ensure the desired comfort. High hygienic standards can be achieved through contactless fittings, automatic flush control for urinals and toilets, easily cleaned

Squatting position

Modified traditional toilet seat

Toilet seat you can lean against

Possible squatting and sitting positions
(From: The Bathroom by Alexander Kira)

materials such as ceramic and stainless steel, odour suction at critical places on the toilet bowl, and water conservation technology.

Technology has had a large impact on toilet design. It plays a crucial role in the development of water and energy conservation solutions, in preventing the vandalisation of toilets, and in reducing maintenance costs. Flushing systems are now installed inside walls, whilst urinal and toilet flushing technology is concealed under plaster. Panels with electronic eyes employ infrared light to 'see' users as they near the facility. Sensory technology for wash basins and toilets is contactless, safe and reliable, regulating the water flow like an invisible hand.

Mobility creates new needs

As our society becomes more mobile, it is not only cosmopolitans who find themselves constantly on the move, but also business people, tourists and families who visit public places such as cafés and restaurants, museums, libraries, schools, amusement parks, sports arenas, railway stations and even hospitals. And at all these places, they use washrooms and toilets that simultaneously serve as company windows. Generally, it is the first impression that stays in a person's mind.

The wealth of literature on toilets is indicative of the great interest people show in this subject, no matter where they live and work, and regardless of their nationality. Municipalities, associations, and health offices issue toilet guides giving brief surveys of the toilets available in their towns or regions. The Internet contains countless sites – private and professional – showing where and in which towns or cities one can find the most appealing and the cleanest free toilets (see appendix).

Given the great public interest, it is hardly surprising to learn that a world toilet association – http://www.worldtoilet.com (with its headquarters in Singapore) has existed for several years now. Its seventeen member organisations come primarily from Asian countries, as well as from the USA, Russia and Great Britain. A few other countries, such as France, Spain and Germany, are associate members. All these associations aim to promote the design of public toilets internationally, taking into account not only cultural peculiarities but also the technological, ecological and legal aspects of toilet construction.

The world association formulates its requirements on contemporary toilet design as follows:

Toilets should be aesthetically designed and their architecture unmistakable. They should have spacious and sufficiently high rooms with abundant natural and artificial light, as well as additional ventilation to provide fresh, circulating air. The materials used should be easy to maintain. There should be access for the disabled and special nappy-changing areas, as well as rubbish and hygiene bins, mirrors and seats.

The Restroom Association in Singapore, which is also the location of the World Toilet Association's head office, appositely summarises its goals: 'Toilets preserve our human dignity and privacy. (...) Poorly designed toilets deter not only visitors and tourists but also investors, thereby creating a negative brand image that can only be remedied by expensive advertising.'

Design concepts for toilet interiors

Before we turn to design concepts, let us take a brief look at the toilets at 'in' pubs and cafés, where gags and humour are employed to entertain guests, making these places the talk of the town. It is usually the proprietors, blessed with a rich imagination, who come up with the ideas that draw the customers. In some places, the mirror above the washstand is missing, providing a surprise glimpse into the men's room; in others there are no partitions in the ladies' room, which provides an excuse to continue conversations indefinitely. This genre of toilets, which is not the focus of the present book, is characterised by its use of whale song, twittering birds, artistic objects, bizarre surfaces and decoration, and so on. In Austria, we find toilets of a very special kind. At the Hotel Zum Römischen Kaiser, for instance, the popular phrase, "[the place]... where the emperor also goes on foot" has inspired a marketing idea: the first Hotel Europe with adventure toilets, which was completed in 1998. Four large adventure toilets lure tourists inside and confirm the hotelier's guiding principle: 'We must restore the toilet to its former position in people's lives'.

All the examples in the present book are taken from buildings with an integrated design concept that also includes their toilets. The washrooms in the Syrian restaurant *Saliba* are reminiscent of an oriental brothel, and the urinal areas in the *Buddy*

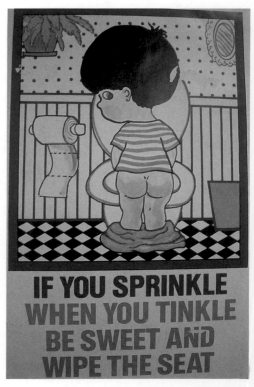

School poster admonishing children to keep toilets clean (by Restroom Association Singapore [RAS])

Hotel Zum Römischen Kaiser, Austria

Musicaltheater exhibit theatre props. The toilets in the elite *Nasa* club in Copenhagen, on the other hand, are painted in the same spacey white as the club itself. Those in the Swarovski Kristallwelten, designed by Andre Heller, have the same fiery colours as the entrance hall. In the Italian restaurant *Torre della Sassella*, the toilets are integrated into cavities in the rocks and have the kind of dramatic lighting normally found in open-air theatres. In the *Disco*, in São Paolo, the toilets are black: the glass washbasins and the stainless steel urinals area are only discernible thanks to powerful lighting effects. Then there are toilets with a homely character and those that are artistically designed to defamiliarise the space. Still others have a 'room with a view'. The toilet interiors display imaginative, individual, colourful and sensuous designs that are enhanced by the choice of materials: the floors and walls are tiled or finished in natural stone and glass, fine woods and colourful paints, concrete and artificial resins. The sanitary appliances are made of ceramics, glass and stainless steel, with optical-fibre technology being employed to dramatic effect.

These toilet interiors are full of surprises, subtleties and innovative ideas, and satisfy the desire for modern design: they are emotive, playful and artistic.

Washrooms for communication and relaxation

Many restaurateurs are well aware of the significance of toilets and washing areas as places where people can retreat, chat and even get to know each other. For this very reason, washing areas for men and women are frequently given unisex designs. 'It's a good way of meeting people, because their paths always cross to the toilet anyway.' (Thorwald Voss, the *Supperclub*). No nation is less inhabited than the Dutch when it comes to toilet design: they generally construct unisex toilets with a playful, humorous designer touch. At the *Supperclub* in Amsterdam, for instance, the toilets are black (hygienic white rooms, it seems, are simply not conducive to flirting) with large seat blocks in the middle of the room where people can make contact and chat. Like Hamburg's Side Hotel, the *Palladium* events centre in Cologne has very spacious washing areas, with a central 'wash fountain' in the middle. At his opening concert in Cologne, rock musician Lenny Kravitz was so knocked out by the toilet that he immediately moved his press conference to the washing area.

Although the architecture of other public buildings such as museums, training centres, service areas and leisure centres has changed over the past few years, the attention given to toilet interiors has generally focused on their purely hygiene function. What did Colin See of the Restroom Association in Singapore say? 'The standard of toilet fittings and design does not correspond to our society's level of civilisation. It clearly shows how much respect proprietors show their customers and visitors.' Retailers have a lot of catching up to do here, since they generally only provide customers with specially designed toilets in their large stores and in shopping malls. It is all the more surprising to hear the following story from design professor Rainer Gehr: In 1974, Hans Hollein, the now famous architect from Vienna, constructed a tiny (13.5 square metres) but very high-class jewellery shop in the centre of Vienna. The Schullin became renowned for its 'broken' decorative façade. At the time, Hollein explained in a lecture that he had been commissioned to design a superb-looking spacious toilet, located behind the salesroom, where the (mostly male) customers could carefully consider imminent purchases in peace and quiet.

Toilets as stress-free zones

'Lavatory luxury comes to a head.' This was the title of a revealing article in the *Los Angeles Times* (11 June 2001) on toilets in administration buildings. Semi-public toilets probably serve the most important function in companies, training centres, educational institutions and administration buildings, in other words, in all those establishments where people frequently spend anything from a few minutes or hours to the entire day. The hectic working atmosphere often found in open-plan offices and small cubic offices creates a need for space where people can retreat and relax, and perhaps even come up with new ideas. Some design and advertising agencies are already providing their staff with a creative room equipped with sofa beds, mellow lighting and soft music. In most companies, however, this need is inadvertently met by the washroom, where staff can meet on an informal and trans-hierarchical basis and chat about the company, work issues, fellow staff members or themselves. It is probably the only room in the company where people can venture to say things they could never mention in the office. Staff interaction is one of the most important concerns of any company, and the washroom could, given the

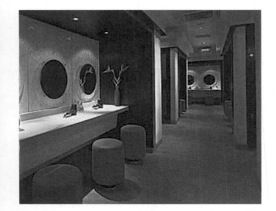

Amida Racquets and Fitness Spa, UK
(Design: Corporate Edge, London)

right design, assume the function of a crisis-management centre – a stress-free zone. This idea dates back to the early twentieth century when, in the USA and Europe, small salons were established with sofas, a small bar and lavish decoration for tired theatre- and opera-goers. Nowadays, some architects still add social rooms to the washrooms to create the desired quiet zone.

Companies that offer their staff and customers designer toilets reveal – where one would least expect it – a lot about their corporate culture, their attitude towards design and the esteem in which they hold the users of their toilets. Painstakingly designed toilets offer staff members, guests and customers a place to relax, be alone or communicate with others in a way that can be very different to the type of communication that takes place in conference rooms.

This book provides some suggestions and ideas on toilet design in the hope that people will not content themselves with merely seeing these small rooms in a new light but design them in new ways too.

From the Cultural History of the Toilet

Bourdalou – the pot for the longwinded preacher. The Jesuit preacher Louis Bourdaloue (1632-1704) was known for the bold and (often) interminably long sermons he held at the court of Louis XIV. Quite unceremoniously, the court ladies – fascinated by his addresses yet incommoded by their length – took gravy boats to church, where they were put to an entirely new use. Manufacturers capitalised on this practice by developing the pot de chambre oval, which only years later was named after the preacher. The court ladies are said to have smuggled these bourdalous into church in their muffs and to have slipped them under their skirts when their need was greatest. This vessel was also highly popular on journeys, and as late as 1980, a model of this once so widely used utensil was placed at the disposal of female travellers in a corner cabinet of Bundesbahn sleeper cars (see Bourdalou Museum in Munich, p. 92).

Klobrille – German for 'toilet seat' (literally 'toilet eyeglass'); Brille (eyeglass) is derived from the Late Middle High German word berille, itself related to beryl. Around 1300, people made lenses of beryl and other polished semi-precious stones. The word Brille in Klobrille is an allusion to the toilet seat's protective function. It was apparently intended to help users distinguish between the 'clean' and 'unclean' side of the toilet.

Latrine – from the Latin words lavatrina, latrina – the washing and bathing room in ancient Roman farmhouses. What the Romans called latrines were public facilities that had toilets with several seats. They were intended for people (particularly merchants and travellers) who had no slaves of their own to clean and empty their sanitary vessels. The communal toilets disappeared as urban areas grew wealthier and there was a greater desire for privacy. Latrines with many seats were also existent in Africa, Germania and, later on, in the military (see p. 74).

Loo – a British word for toilet, probably a mutation of the French 'Gardez l'eau' – the warning people cried out when they emptied a chamber pot into the street. Recent interpretations link it to the French 'bourdalou'.

Chamber pot – was the primary means of disposing human waste before the invention of the toilet; it is now found in children's rooms and hospitals. The chamber pot can be made of porcelain, metal and plastic, and it used to be concealed in various pieces of furniture, including armchairs, stools, secretaries, chairs and tables (see Chamber Museum in Munich, p. 90)

00 – these numbers appear on lavatory doors in officials buildings where all doors are numbered. They are a rather shamefaced way of identifying out-of-the-ordinary rooms.

WC, Water Closet – around 1589, Sir John Harrington invented a hand-operated water closet which, three years later, was installed in the palace of Queen Elizabeth I. In 1775, the London clockmaker Alexander Cummings invented the S-trap based on the principle of communicating pipes. It still is a central component of WCs today. As early as 230 BC, the Greeks made use of siphons (a system of water and suction pipes) to keep odours from rising from the sewage system pipes. In 1847, the English issued a regulation for efficient toilet cisterns that imposed high fines for exorbitant water consumption. Around 1870, the English developed a pedestal closet – a kind of free-standing ceramic toilet that was more economical than its predecessor. In 1796, a British patent was awarded for a pan closet that consisted of a ceramic bowl and a pan-shaped piece of metal underneath. A large number of these pan closets continued to be used in the twentieth century. The 'long hopper' did without complicated mechanics: it had a siphon and was cleaned by a fine jet of water. For many years it was the favoured toilet of the poorer classes, including domestic servants and factory hands. The first wash-down and wash-out closets date to 1880 and are still used with slight modifications today.

Cafés & Restaurants

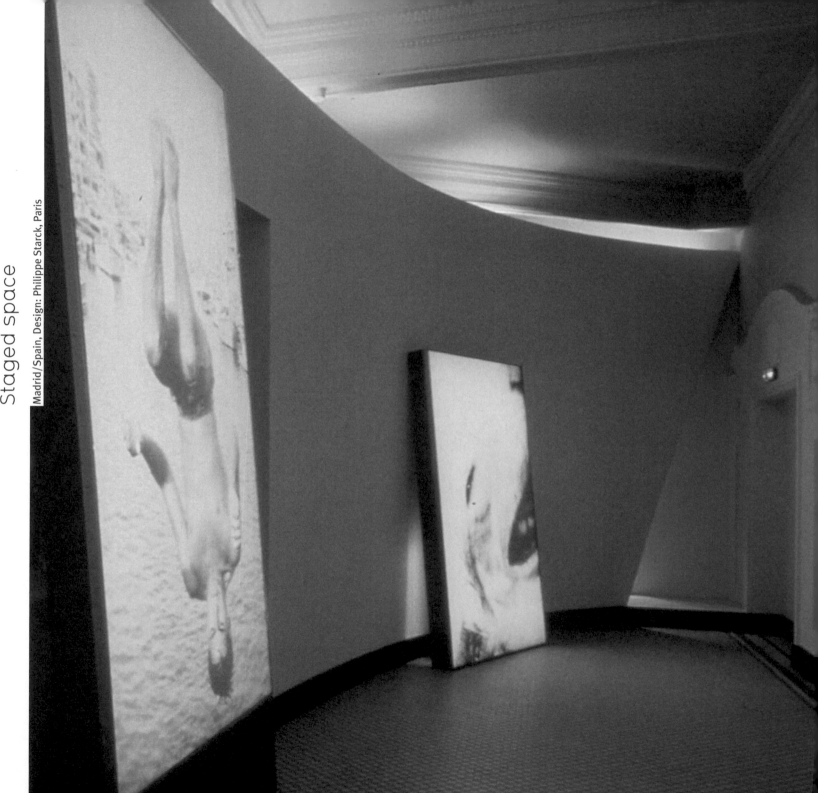

Teatritz
Staged space

Madrid/Spain, Design: Philippe Starck, Paris

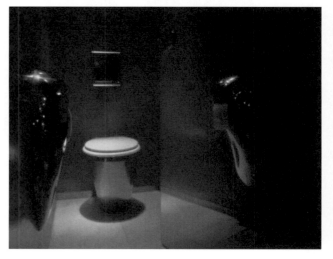

The restaurant, formerly known as the *Teatro Infanta Beatriz*, is situated in the centre of Madrid. Philippe Starck converted it into a large Italian eating place by adding several bars, a disco and a small ballroom, including some surprising effects. A huge velvet theatre curtain envelops the circular dining area, creating an atmosphere that is unusually intimate for a restaurant of this size. The curtain opens in a sweeping gesture to reveal the former stage where – inspired by Salvador Dalí – an oversized onyx bar, illuminated from within, dramatically offsets the tables. Wherever they cast their glance, visitors are struck by the contrast between the old theatre and the new design. Broad wooden frames transform rooms into pictures, doors are made of glass, whilst leather and velvet symbolically integrate the guest into the setting. The toilets deserve special mention. In the anteroom, large, dramatically back-lit photographs displaying water motifs are leant against the wall. A glass entrance in blue and red creates a night-club atmosphere. In the men's toilets, the water runs over a breathtaking block of marble with silver and gold ornamentation. In the ladies', a mirrored lance-shaped corner washbasin reflects light and images in all directions. Staged space.

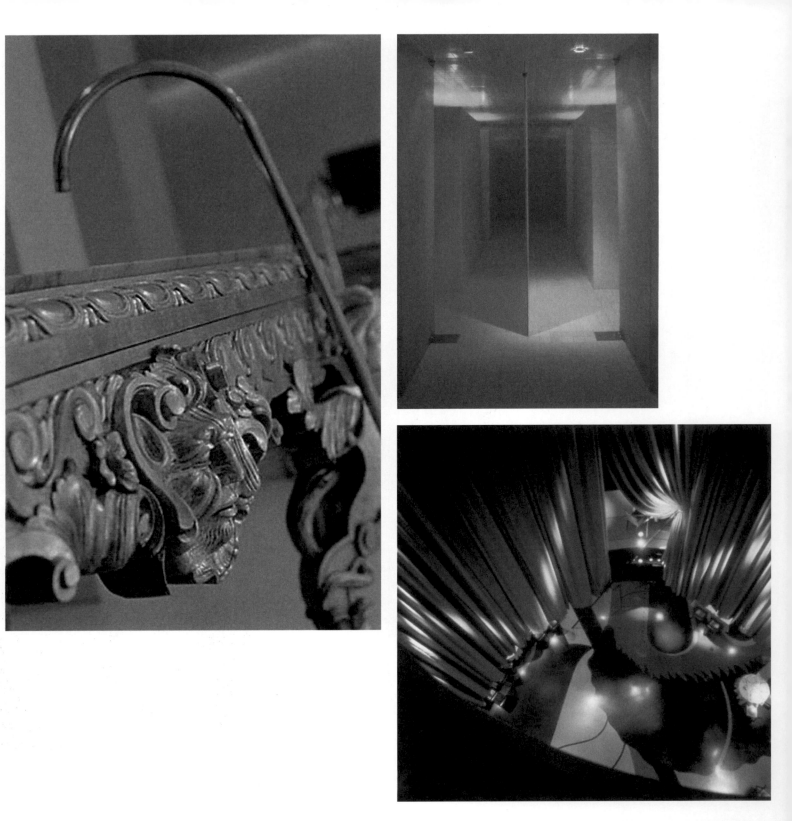

Cafés & Restaurants

00 – Zero-Zero
A hall of mirrors

Florence/Italy, Architecture: Studio d'Architettura Simone Micheli, Florence

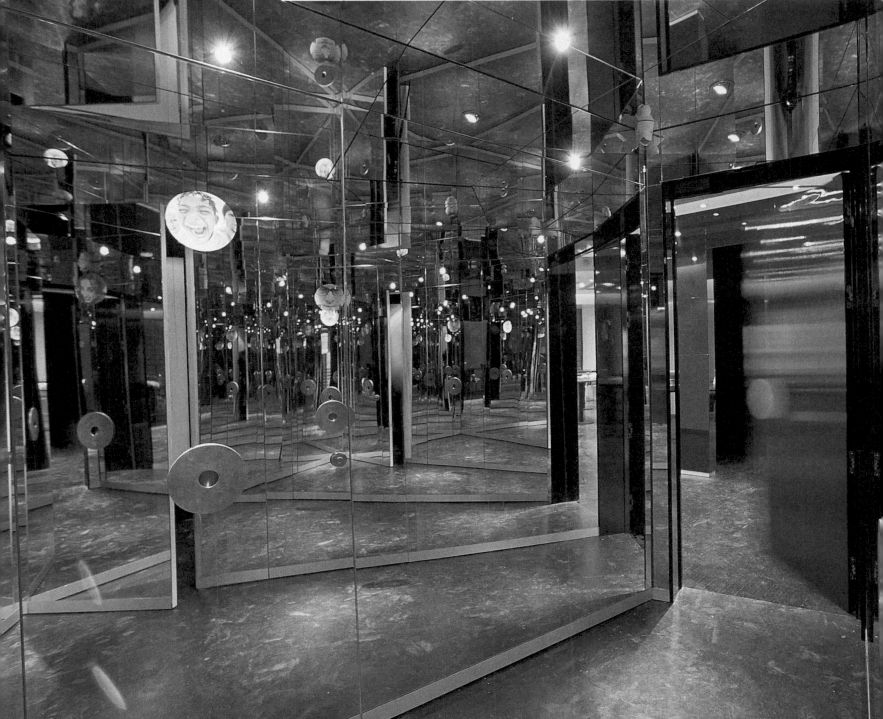

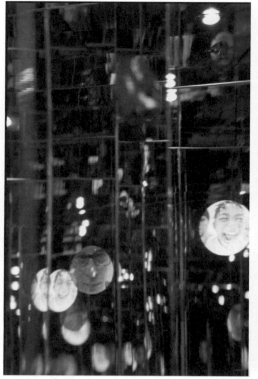

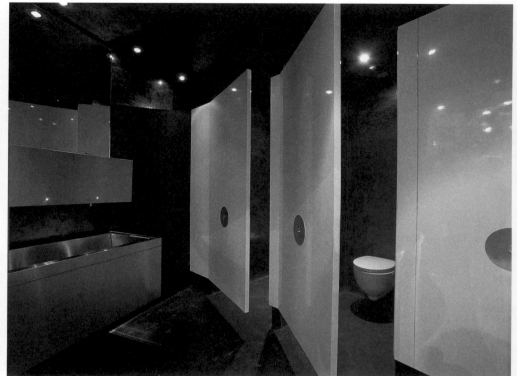

The two zeroes in the name stand for the foundation of all life, which in this restaurant means elevating the pizza to the status of an artwork. Projected into a futuristic age, the restaurant has been given an almost extraterrestrial atmosphere, with cineaste light effects, mostly black materials and mirrored walls that reflect the room ad infinitum. In the washing areas, too, the spatial boundaries and even reality itself are called into question. The funnel-shaped washing area is completely clad in mirrors. The doors to the toilet cubicles are identifiable only by their round disc-shaped handles and the laughing black-and-white portraits, which transform the washing area into an entertaining hall of mirrors. All the washing areas and toilets are finished in black-and-white synthetic resin. Both the long washing trough and the fittings have been executed in stainless steel. The soap dispensers and towel dryers are sensory controlled. Only the children's toilet displays cheerful colours: the walls, ceilings and floor are clad in colourful mosaic, and the rooms appear to flow into one another.

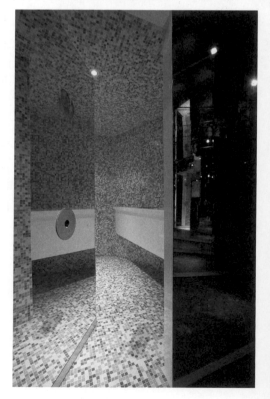

Lindenlife
On the rocks

Berlin/Germany, Toilet Design: Stephan Vogel and Jentsch Architekten, Berlin

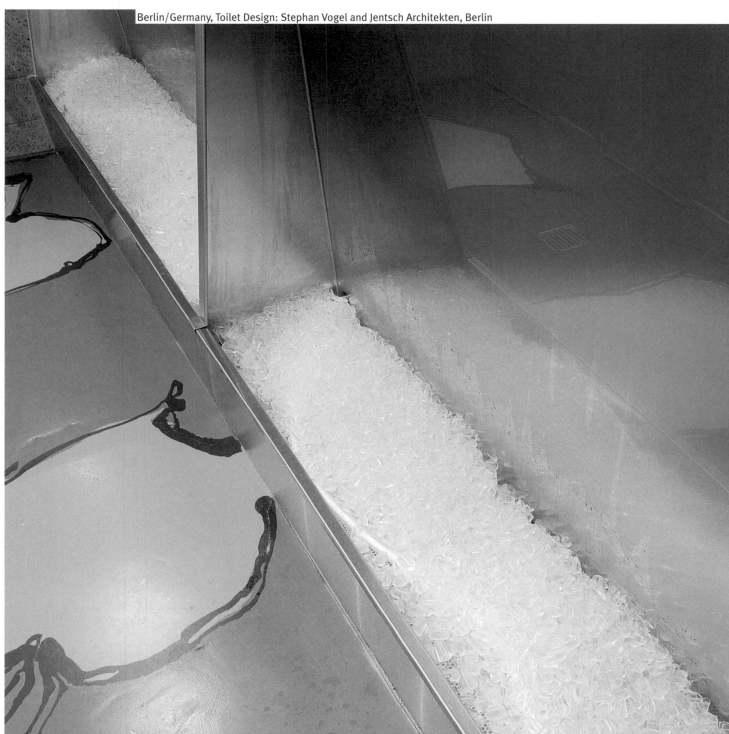

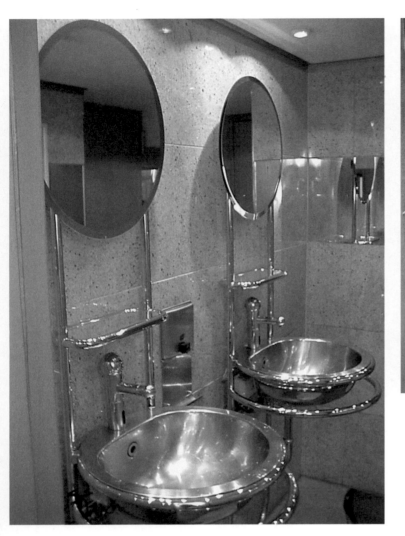

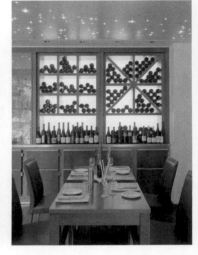

Lindenlife,

a catering complex with a glass TV studio and a wine bar in Germany's Parliament House in Berlin, stands on *Unter den Linden* opposite the Russian Embassy, only a stone's throw from *Brandenburg* Gate. Proprietor Stephan Vogel (a former journalist and a real trendsetter when it comes to presenting events) has created a unique communications centre to suit the needs on his clientele, who are mostly members of the government or media representatives. Throughout the building, Zumtobel's use of light is simply amazing. The men's toilets are quite an experience for the male guests: the urinals are bathed in blue light emanating from bottom-lit crushed ice, which not only looks fresh, but also neutralises the smell. The ice is piled up in front of an artificial waterfall and renewed two or three times a day. Stephan Vogel sees the toilets as both good advertising for the building and as a reflection of the cleanliness of the kitchen. Marble and stainless steel are not only ideal materials in this respect, but also communicate high value. The coloured synthetic resin floor intensifies the magical lighting of the loo and calls to mind the large leaf motifs – taken from the lime tree – in the company logo.

Lenbach
The seventh sin

Munich/Germany, Design: Sir Terence Conran, CD Partnership Ltd., London

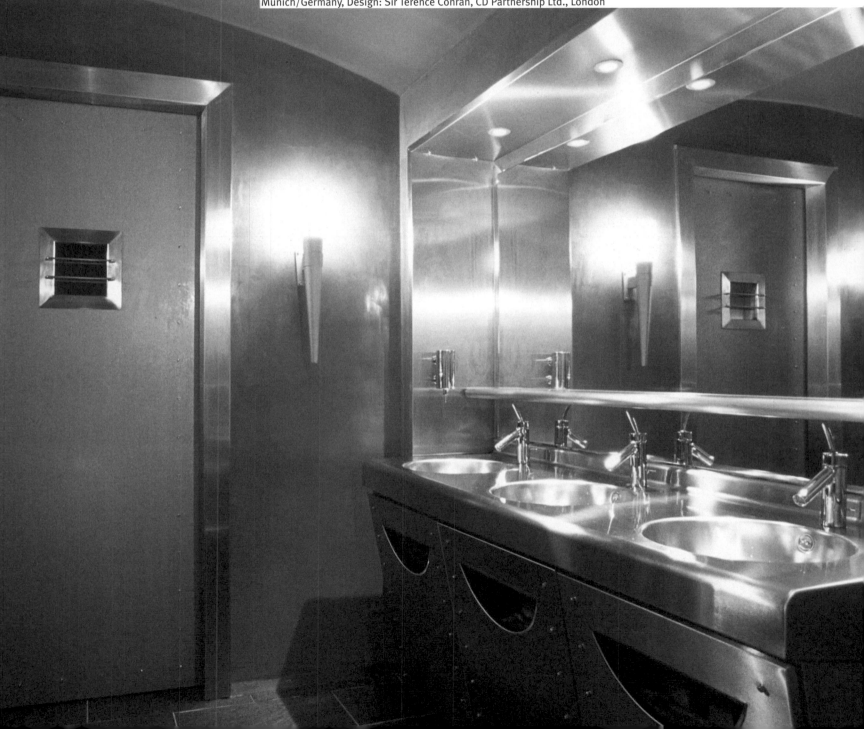

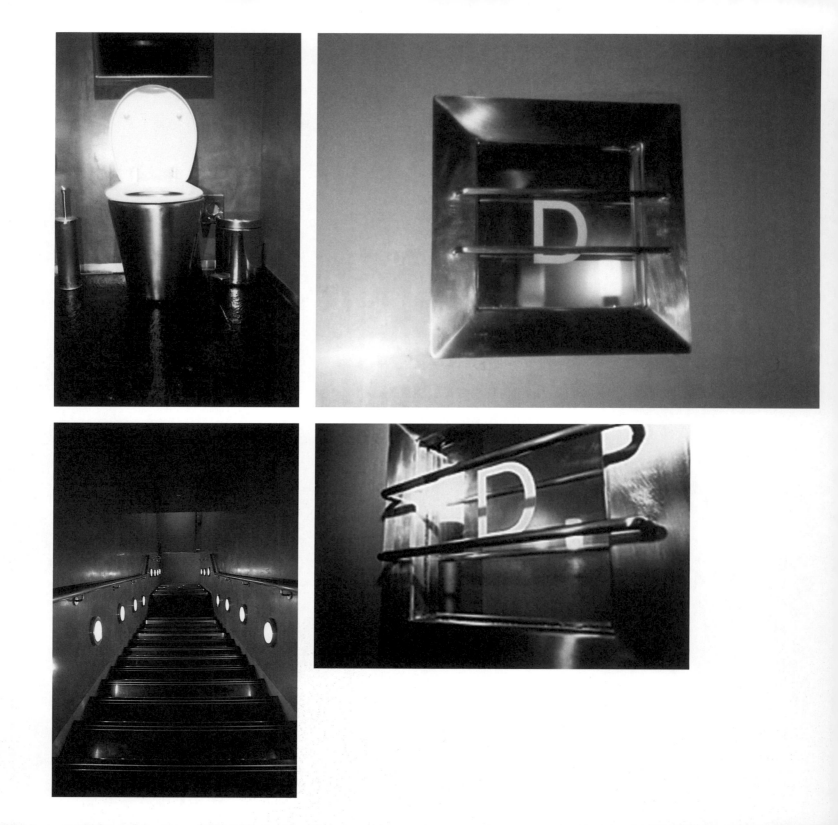

In the late nineteenth century, *Lenbach* was a private and commercial building owned by the Jewish merchant Bernheim. In the 1980s, it was named *Palais am Lenbach*, after Lenbachplatz, the square where it stood. The historical setting is perfect for an XXL pub with two bars and a restaurant that combines the traditional with the modern. With his design, Sir Terence Conran has allocated each area to one of the 'seven deadly sins': greed, envy, lust, pride, gluttony, sloth and anger. The very sight of *Lenbach*, whose entrance with its gas-lit torches creates an aura of pathos, is supposed to awaken envy in the guests. Whilst the aromas in the café stimulate lust, the bottom-lit catwalk in the restaurant offers guests an opportunity to openly display their pride. A glance into the open kitchen arouses greed in the guests, before they succumb to the next sin – gluttony. They finally find relaxation on the soft sofa in the gallery. From the foyer, a staircase leads down to the toilets, whose theme is anger. There, the barred stainless steel doors create a prison-like atmosphere. The heat of anger is expressed in the deep red of the walls and ceilings, which gleams in the light of the torch-like wall lamps. The stainless steel washbasins, sanitary appliances and fittings all communicate toughness and aggression, an impression reinforced by the hard, black slate floor.

SuperGeil
Futuristic design in red and orange

Copenhagen/Denmark, Design: Johannes Torpe, Copenhagen

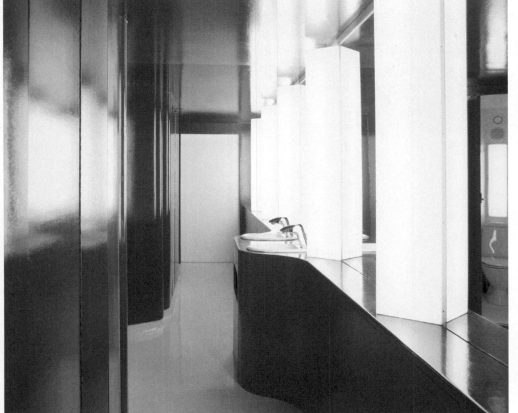

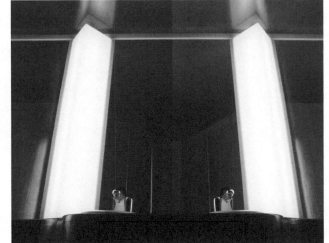

Actually, the client wanted a pretty café, with a Scandinavian touch, that served Danish food. But then the designer carefully studied both the surrounding area and the target group and came up with a café whose futuristic design not only addressed the ambience, but also included specifications for the menu, the music and even the staff training. This concept was to supposed be transferable to a wide variety of towns and cities. However, this idea was shelved following the events of 11 September 2001. Three WC cubicles, each with a small washbasin in the corner, stand side by side in a long room. The rounded plywood walls are finished in coloured epoxy gloss paint. No distinction has been made between ladies' and men's toilets (they are designed for use by both sexes), although people do have a choice between red and orange WCs. For guests who wish to stay and chat for a while, or attend to their appearance, there are two small washbasins – framed by high, triangular columns of light recurring along the wall – on the long red front opposite.

Les Philosphes
Basic questions of Kant's philosophy

Paris/France, Design: Xavier Denamur, Cafeine, Paris

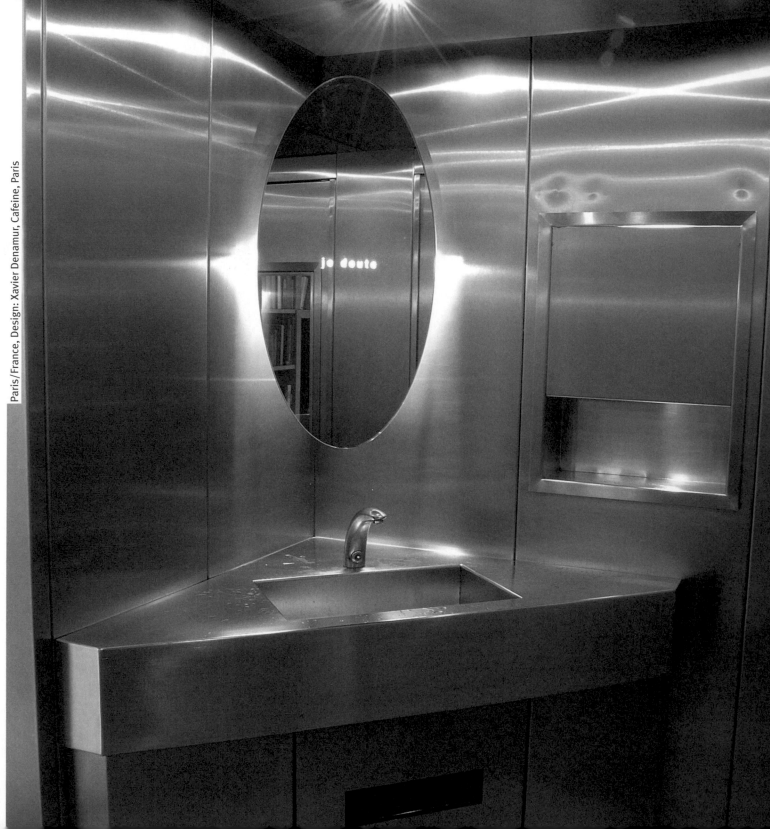

Les Philosophes is located in the middle of the historical quartier of Marais in Paris. Alongside tourists, its guests include a healthy mixture of artists, architects, journalists and students. The café's name was inspired by the early philosophical studies of its proprietor and is now, in fact, a weekly meeting place for philosophers. Xavier has designed brilliant toilets for all his cafés. Here, in *Les Philosophes*, the toilets are clad entirely in stainless steel, although the floors, in contrast, are laid in mosaic and depict Dionysus, the Greek god of wine. As the café is completely devoted to philosophy, its guests are confronted with this subject at every turn. Although they are free to interpret Kant's three fundamental questions – What can I know? What ought I do? What may I hope for? – however they choose, they cannot leave the toilets without reading an answer to these questions in the mirror: 'Je doute' and 'J'ai conscience'. The bookshelf in the display cabinet between the toilets is a private joke on human nature. The first books the women see are 'the declaration of human rights', whilst the men find themselves looking at books that have largely been written by women.

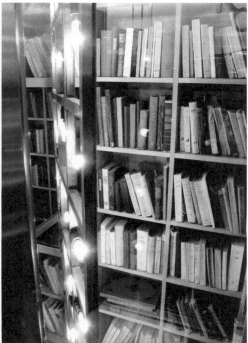

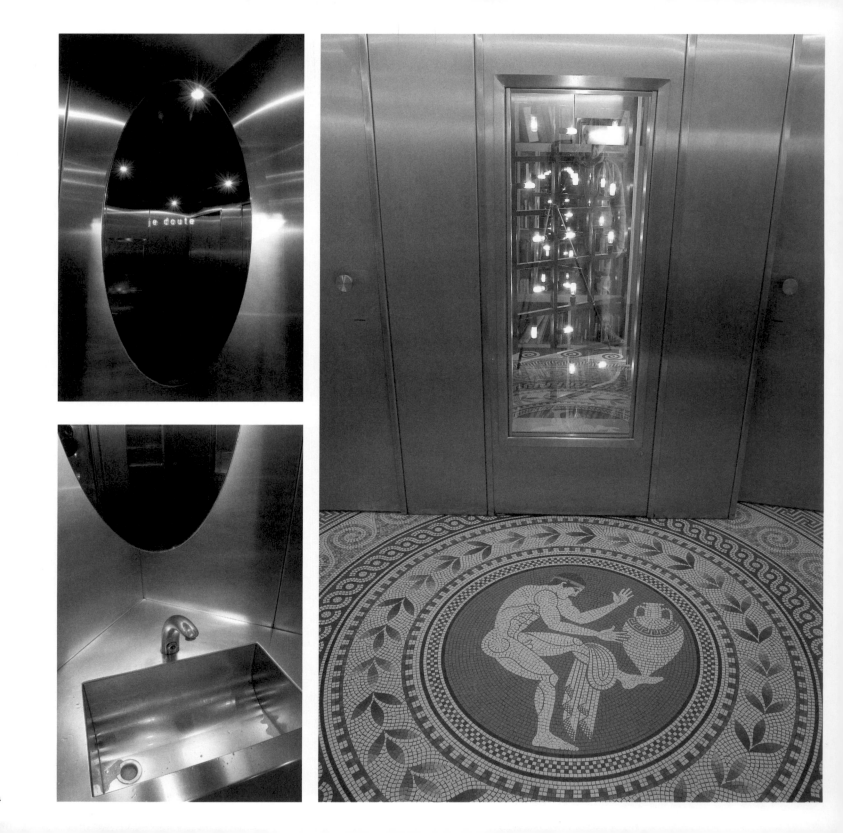

Torre della Sassella
A tower set in light

Sondrino/Italy, Architecture and Light Design: Consuline, Francesco Iannone, Milan

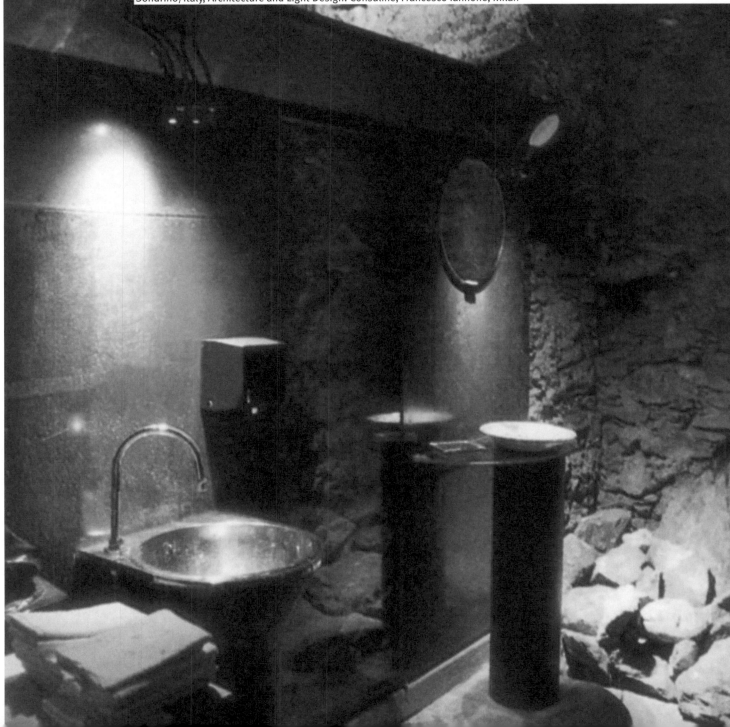

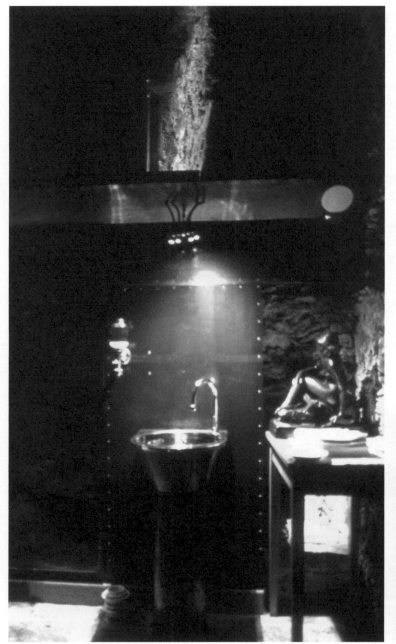

High up in the vineyards of Sassella stands an old lookout tower dating from the twelfth century. This structure, which served as a military observation post in the eighteenth century, is considered to be one of the finest buildings in Lombardy. It is now home to the *Torre della Sassella* restaurant, which occupies five stories and includes a panorama hall, seven smaller halls, and a wine cellar with a wine-tasting room. Care has been taken to preserve the building's medieval character, with rocky niches and projections put to functional and decorative use. The floors are covered with natural stone tiles. Scenographic illumination using optical-fibre technology lends each room a special atmosphere. Each floor is enlivened and distinguished by natural lighting.

The same stunning lighting concept has extended to the toilets. The WC cubicles consist of freely standing steel cylinders set in the rock face. Copper plates in front of the rock walls form washing areas. Stainless steel washbasins, glass shelves and decorative tables for hand towels have been used to create a very intimate ambience here.

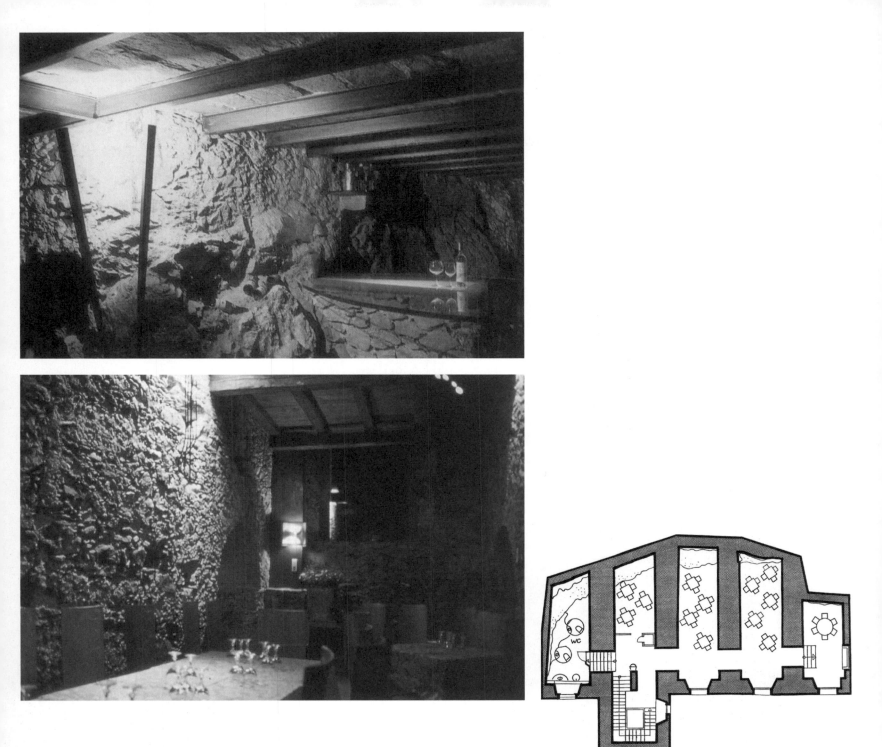

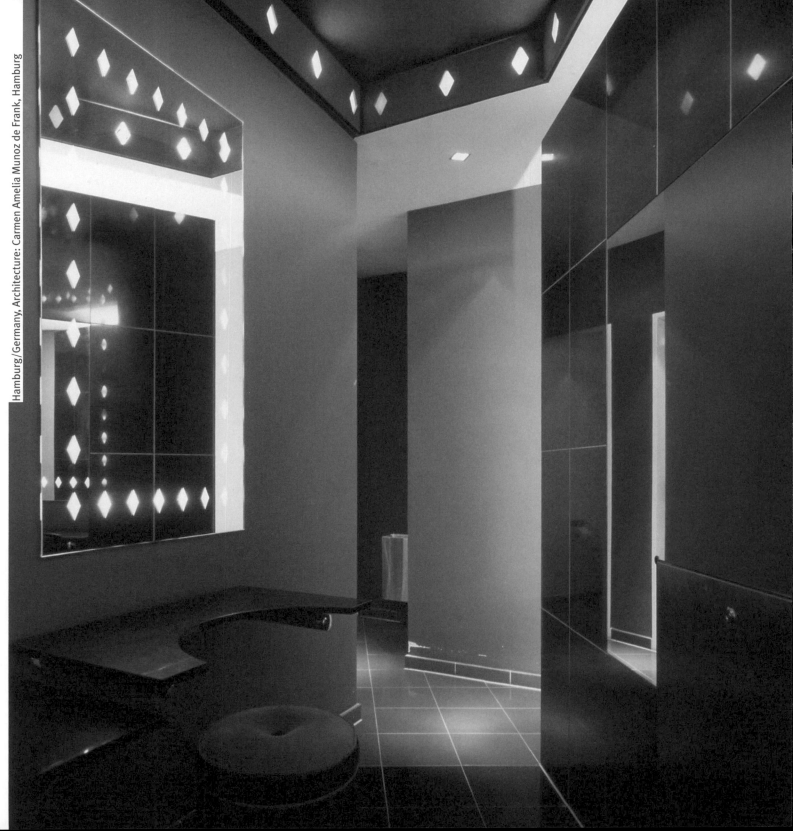

Saliba
The oriental art of relaxation

Hamburg/Germany, Architecture: Carmen Amelia Munoz de Frank, Hamburg

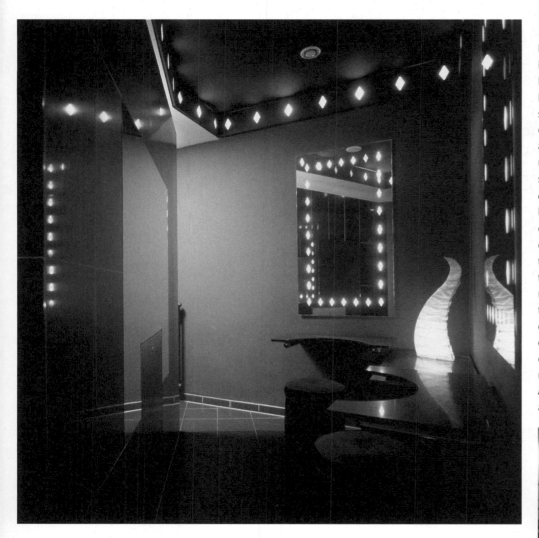

Saliba, a Syrian gourmet restaurant, is located in a rather plain-looking industrial building (formerly the Bahrenfeld power station). It has been designed to create a stunning atmosphere that brings together the orient and the occident. A large salon containing comfortable divans and windows covered with traditional wooden screens (known as mashrabiyas) captures the atmosphere of everyday Syrian culture. The rooms could almost come straight from one of the fairy tales in *A Thousand and One Nights*, and are full of hundreds of tiny lights (ring-shaped ceiling lamps) that are reflected on the coloured floor tiles. Their form and discreet colours give these plain rooms and niches an oriental air. One of the side entrances, which leads to the toilet, is furnished with small showcases. The cinnamon-coloured walls and floor tiles invite guests to linger. Like the large mirror in the washroom, the dark-blue ceiling is framed by a frieze of back-lit diamonds, making guests feel as if they are in their own private chamber or boudoir. The colours, aromas and subdued decorations pamper the senses. A little piece of the orient to which guests can come and relax.

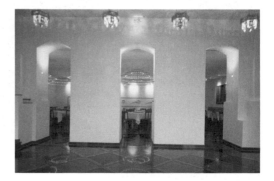

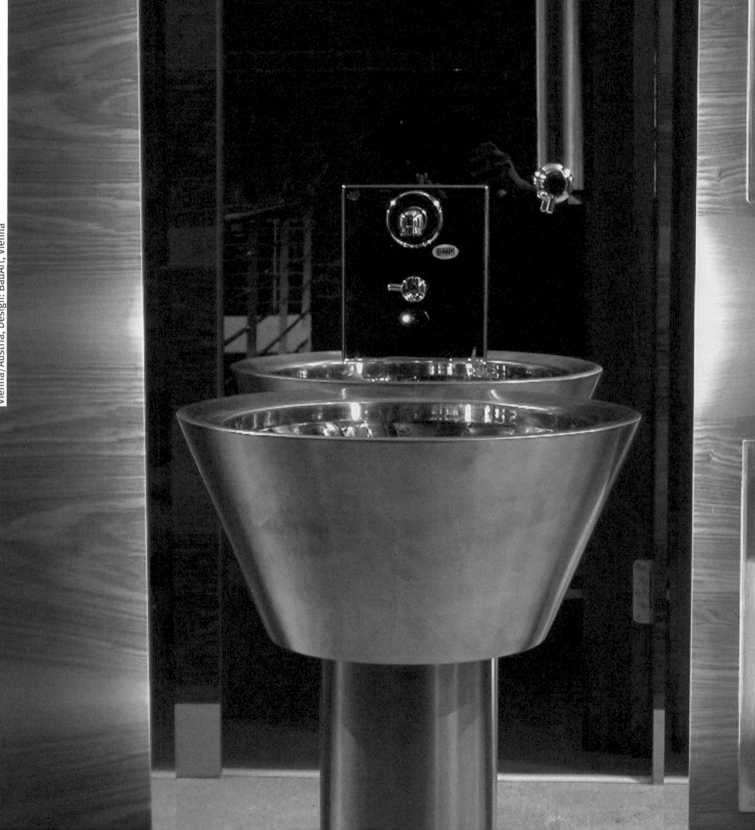

Babu
Exciting ambience beneath the arches

Vienna/Austria, Design: BauArt, Vienna

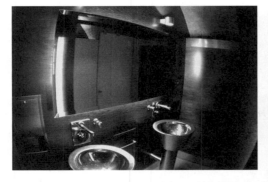

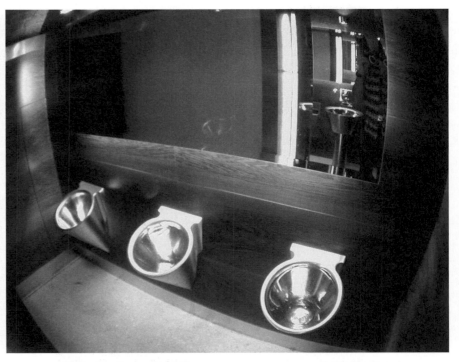

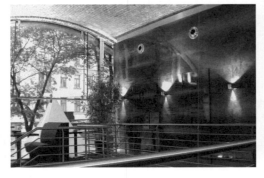

What makes Vienna's railway system a work of such outstanding significance is Otto Wagner's architecture. Wagner created this brick-and-iron axis, which is so important to the city, in the late nineteenth century. Now there are plans to put more than forty walled-up railway arches to new use and create a cultural mile and meeting place for the in-crowd. *Babu*, a restaurant and club in one, is located under the highest of the arches. The long bar, which links three of them, forms *Babu's* pulsating heart.
The brick vault of the railway arch was carefully exposed, and an almost homely atmosphere was created using modern materials such as fair-faced concrete, glass and stainless steel. A wooden cube of Caucasian walnut contains the service wing and the toilets. The curved long side of the cube takes up the curvature of the vault. A particularly aesthetic solution is the choice of stainless steel sanitary appliances for the WC area: they not only reflect the warm colours of the wooden surface but also interact appealingly with the sealed concrete floor. All in all, a simple but exciting ambience within the old brick walls.

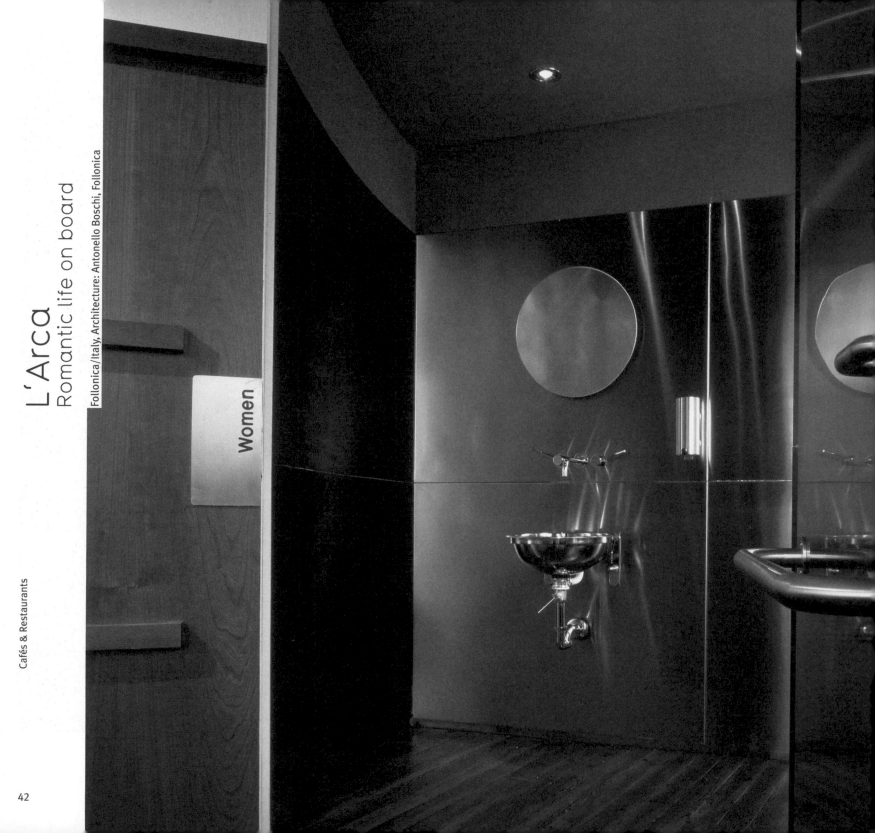

Cafés & Restaurants

L'Arca
Romantic life on board

Follonica/Italy, Architecture: Antonello Boschi, Follonica

Women

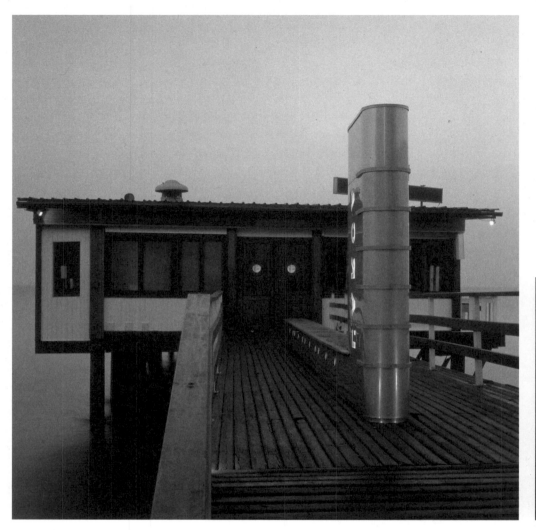

At one time, *L'Arca* was a simple beach house on the coast of Follonica in Tuscany. Now, a huge stainless steel fin on the landing stage points the way to a music restaurant that offers a beautiful ocean view to tourists and families by day and to young disco-goers by night. The design delightfully combines the features of an old wooden house with modern elements. Floor lights set into the ship's planks direct customers to the bar, whose supports are clad in stainless steel. In the clubroom, a stylised sky of glass clouds invites customers to while away the twilight hours by the sea. The toilets have the same modern touch: stainless steel walls with a round mirror and stainless steel washbasins are set out beneath a starry blue sky which, together with the planked floors, has the air of Romantic life on board ship.

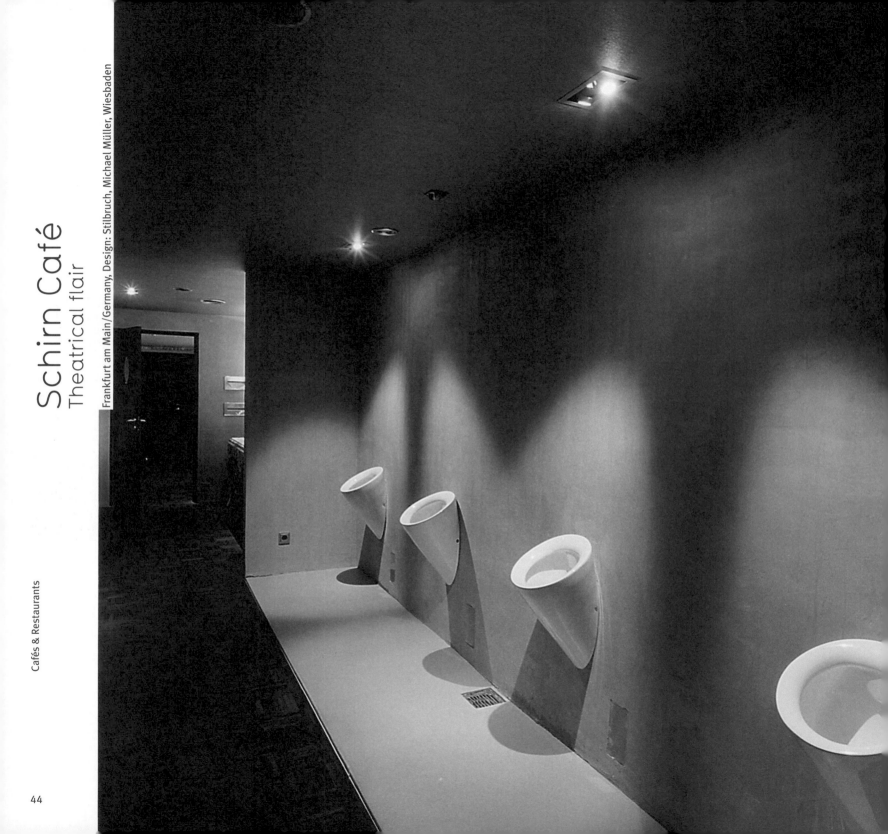

Schirn Café
Theatrical flair

Frankfurt am Main / Germany, Design: Stilbruch, Michael Müller, Wiesbaden

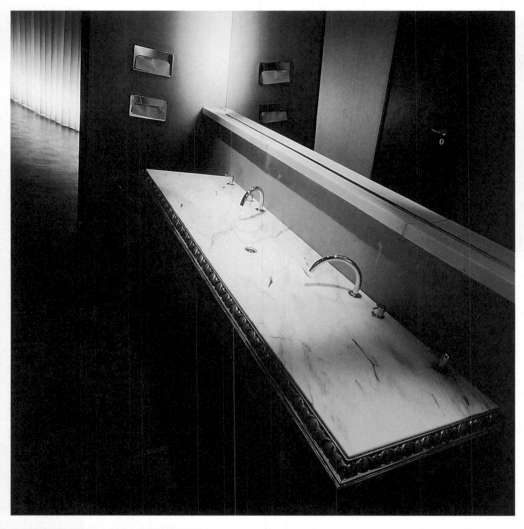

The *Schirn Café* is situated next door to *Kunsthalle Schirn*, not far from the Gothic cathedral, in the very heart of Frankfurt. It provides a setting for encounters, both of the banal everyday variety and of the kind that call for grand gestures. The restaurant's 40-metre-long bar was designed by the Spanish architect Alfredo Arribas many years ago. However, the former city café has been converted many times over in a style that has been, by turns, elegant, cosmopolitan, playful and theatrical. As a result, *Schirn Café* now has the look of modern theatre in a historical ambience. The design of the basement toilets is an integral part of this theatre concept. Guests follow a long white curtain along the curved corridor all the way down to the washing area, where a fireplace and standing lamps produce a pleasant atmosphere. Contrary to standard practice, the dark parquet flooring has been continued into the toilets. The lighting here creates dramatic spatial effects, giving even the urinal area the air of a showroom. In the women's toilets, the water, instead of flowing into a basin, runs across an inclined marble slab. The striking design makes combined use of fair-faced concrete, wooden parquet flooring, marble and frosted glass. A memorable feature is the women's 'Lady P' urinal, which is shielded by a curtain from curious eyes on the outside.

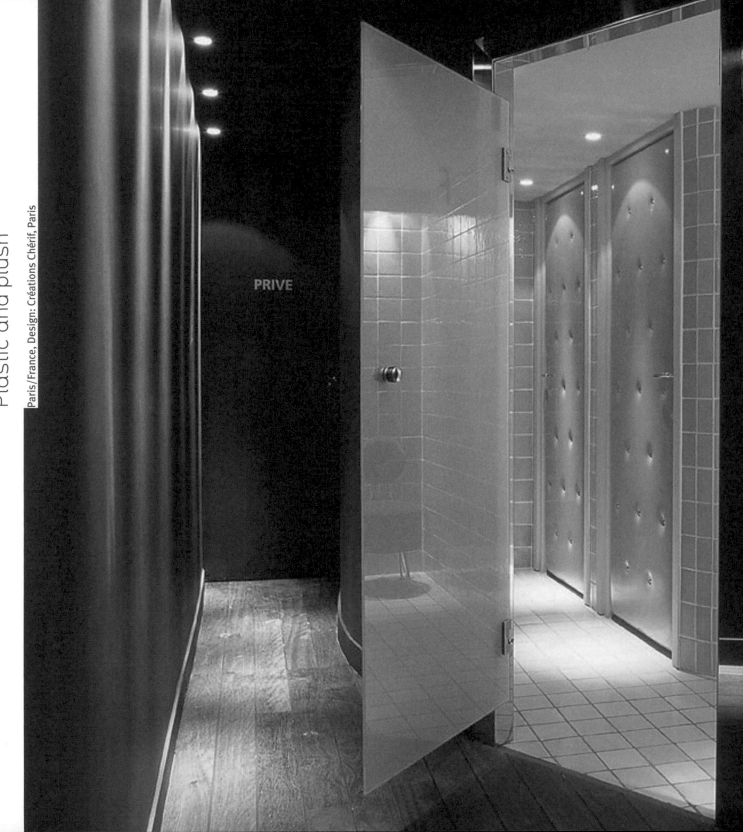

Toi
Plastic and plush
Paris/France, Design: Créations Chérif, Paris

PRIVE

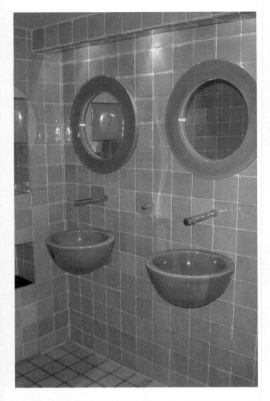

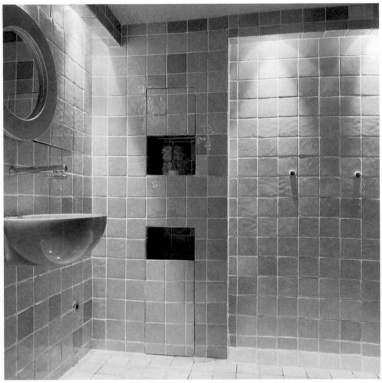

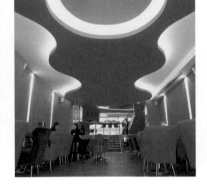

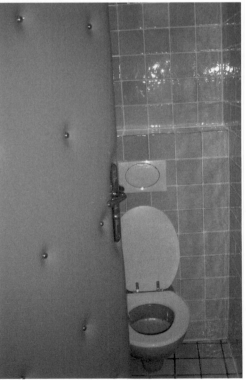

Located in the rather unassuming Rue du Colisée between the Champs Elysées and the Rue du Faubourg Saint-Honoré, the restaurant *Toi* (French for 'you') offers a calm sanctuary for the neighbourhood's busy inhabitants. The Algerian designer Chérif has created an oasis of colour, glass and light – an elegant environment reminiscent of the classic interiors of the 1950s - 1970s. The walls, ceilings and soft padded armchairs are a warm red, and the bright white light emanating from behind the organic ceiling shapes creates a Mediterranean atmosphere. Dark parquet flooring adorns all three levels of the building and leads down to the toilets, where guests are engulfed in the fragrance of vanilla and treated to the sounds of chirping birds. With their broad stainless steel frames, the semi-transparent glass doors are harbingers of the special space within, which features hand-painted light-blue tiles for men and pink for women. Instead of a urinal basin, the men's room is equipped with a simple tiled wall on which a small nozzle sprays water in fanlike patterns. Cutting-edge sensor technology controls its quantity and duration. The padded doors of shiny pink plastic are a particularly surprising feature of the women's room. They give the cubicles a mysterious and private character. No doubt the soft red chair in the anteroom has made the wait more bearable for many a guest and best girlfriend.

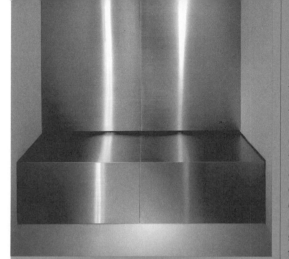

An automatic toilet for Inax

In the year 2000, Japanese designer Tokujin Yoshioka from Tokyo developed a trial automatic toilet of stainless steel for an exhibition by Inax, the Japanese manufacturer of sanitary equipment. The toilet is hygienic and anti-bacterial. Its shape embodies the Japanese concept of harmony, which combines beauty, function and technology. It is fitted with a sensor that opens the stainless steel plate lid when required and reveals a ceramic toilet bowl behind a glass wall.

Design: Tokujin Yoshioka Design, Tokyo

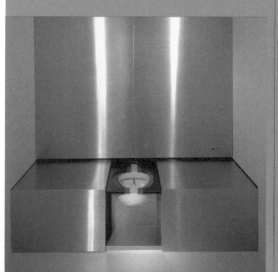

Toilets in the ancient world

As early as 5000 BC, King Midas was using a 'flushing toilet' in his palace on Crete. The toilet consisted of a wooden seat placed over a cavity in the floor through which water flowed, flushing the faeces into a nearby canal. The lavatory was located in a two-by-one-metre room, providing more space than some of our present-day toilets. Many of Mesopotamia's palaces had lavatories with seats that were made of stone or brick slabs arranged to create a gap at the top. The Babylonians preferred privies where they could squat. The wealthy, at least, exploited the abundant supply of water to develop a washing/toilet culture which has evidently long since faded from memory. By 2000 BC, the Babylonians were already using sophisticated drainage techniques that included sewage purification.

Leaching cesspool in Babylonia

Did the first water closet come from China?

In the summer of 2000, the Chinese news agency Xinhua reported an archaeological find dating from the Western Han dynasty (around 200 BC to 24 AD). A stone toilet was discovered in an ancient prince's tomb – a sign that people wanted the dead to enjoy all of life's conveniences in the hereafter. The Chinese toilet even had armrests, a fixed lid and flushing water. All they lacked was paper.

'Bread and Tulips', a film by Silvio Soldini, 2000
Fleeing to a world in which everything is possible

First, Rosalba's plate, with a picture of the sun, breaks in two. Then her wedding ring falls into the toilet, and she finally emerges from the service-station toilet only to discover that her bus has already departed together with her sinewy husband, her children and her relatives. Rosalba hitchhikes to Venice taking all kinds of detours. Once there, she finds her true calling working for the anarchistic florist Grazia; and in Fernando – an Icelandic waiter played by Bruno Ganz – she finds a man who sees in women more than just a suffix to the word 'decoration' (Olaf Möller, film.de). This is a film about the fear of the unknown and the fear of adventure, a film whose wit and sensitivity open up a world where everything is suddenly possible; a film of regional Italian flavour, yet universal, full of love and very funny.

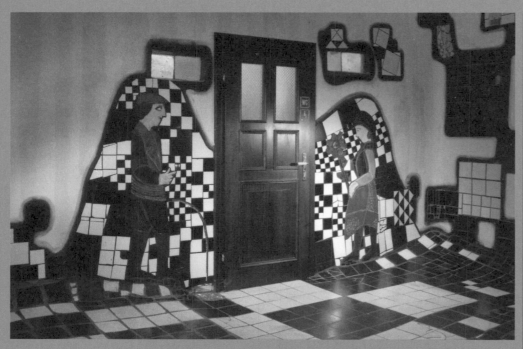

Toilet wall - entrance side

Brecht, Burroughs, Bukowski, Joyce, Roswitha von Gandersheim, Goethe, Rabelais, Swift, Grass, Böll and many others filled pages – and indeed whole chapters – devoted to this subject. Hans Magnus Enzensberger concludes that even the written word could be seen as an excretion. As evidence he mentions the topos that describes the book as a first, difficult or even unsuccessful birth; he cites the (German) expression that this or that author 'könne die Tinte nicht halten' (can't hold his ink/alcohol); he refers to the common conception that writers first ingest something and then digest it, before finally squeezing it out in their work.

Toilet sculpture

In the middle of downtown Rotterdam wonderfully shaped sculptures can be found for those 'desperate moments'. Apparently the Dutch have a rather uninhibited approach to the subject – anyone using this particular specimen is bound to have an audience.

KunstHausWien – Hundertwasser's café

Friedensreich Hundertwasser (1928-2000) described his museum concept as follows: 'I want the KunstHausWien to exemplify an approach to art and architecture which places nature and man back at the centre of the universe. It is a first bulwark against the false order of the straight line, a first bridgehead against the grid system and the chaos of nonsense'. The café is housed in a low museum extension with a grass-planted roof. Inside, black-and-white tiles climbing the wall form life-size images of a man and a woman in front of the toilet doors'.
www.kunsthauswien.com

Toilets in poster columns

In 1854, the Berlin printer Ernst Litfass hit upon the idea of putting urinals inside his round poster columns. He offered to erect and operate thirty urinals at his own expense, on the condition that all public notices be printed in his shop and hung on these columns. He was granted a concession, but then, for reasons of cost, only delivered columns without urinals. Many years later the company Wall revived his idea, transforming Berlin poster columns into toilets with advertising space. They are now used in forty cities in five different countries around the world.

Victor Hugo – 'Les Miserables', 1862

In vain, he compared the outhouse with a cynic, claiming – not wrongly – that the history of humanity was reflected in the history of sewage.

KLO & SO – Museum for Historical Sanitary Fittings – in Austria

The Austrian town of Gmunden on Lake Traunsee boasts what is probably Europe's only museum devoted to toilets. The objects on display were collected over a period of almost forty years by Fritz Lischka, the former works manager at Laufen, the sanitary ceramics manufacturer. More than three hundred toilets, indoor conveniences, water closets, bidets and washstands from many different centuries can be viewed here. Two special features here are Queen Elizabeth's bidet and a rocking tub, not to mention earth closets, chamber pots, commodes and modern flushing technology. Visitors can also study technical developments such as the introduction of the siphon and diverse materials used in toilets such as bricks, lead and ceramics. The museum contains Europe's leading collection on this subject.
museum@gmunden.ooe.gv.at

'Girly' – a urinal for him, her and the kids

This Catalano product is similar to a standard WC (though somewhat smaller) and is designed to accommodate the needs of women, who can push the toilet between their legs instead of having to sit on it. It serves as a unisex urinal and as a comfortable WC for private and, above all, public use. It allows users to adopt a more relaxing position.
Design: Matteo Thun, Milan

Klo – a Berlin scene pub

This rather unusual 'toilet pub' has been serving guests in Berlin for more than thirty years. Draught beer is poured into urine glasses amidst a panopticon of chamber pots, toilet brushes and toilet paper. Popular among tourists and Berliners alike, this pub is half ghost-train and half curiosity cabinet.
www.klo.de

WC Nautilus by Rudolf Ditmar Znaim, 1904

'Downsize' from Chris Welzenbach, 2003 – Theatrical production in the men's room

For twenty-eight minutes, a tense stillness reigns in the men's room of the Cubby Bear, a sports bar directly opposite Chicago's Wrigley Field Stadium. The faint smell of urine hangs in the air as nineteen guests, pressed against the white tiled walls, try to look relaxed. Archie, the story's villain, storms in with four other actors. 'Downsize', as this tale of intrigue is called, unfolds in the middle management of a small company threatened by bankruptcy. The fictive setting is also a toilet. Justifying this selection of venue, the playwright, Chris Welzenbach says: '. . . the audience is on the same level as the actors. Their presence in this non-place awakens in the audience the feeling that they are doing something taboo and hearing things not meant for their ears.' The actor who plays Archie says: 'The audience is damn close to us.' For the audience, this merciless intimacy with the protagonist is fascinating; one can hear every breath he takes and see the tiny drops of sweat on his brow – a radical experience, particularly for the women of the American Midwest, who would never dare enter the men's room.
DIE WELT, 9.10.2003

Bars/Clubs/Discos

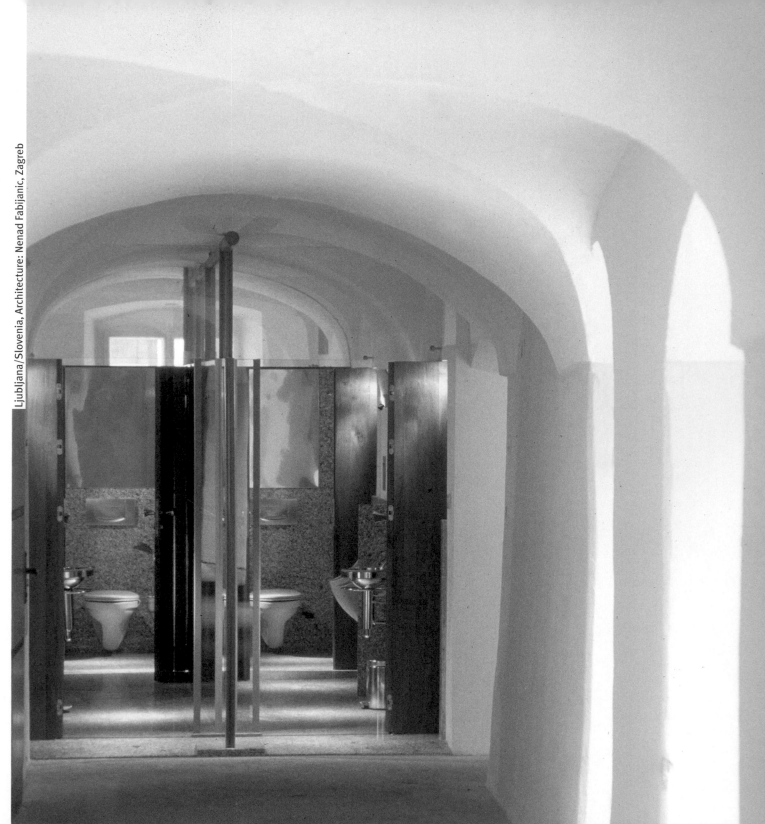

ZeBar
Under the arcades

Ljubljana/Slovenia, Architecture: Nenad Fabijanic, Zagreb

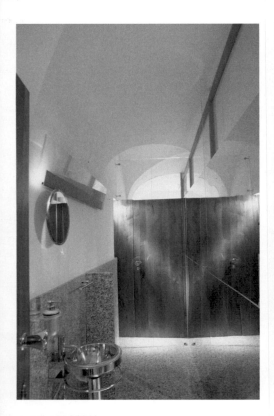

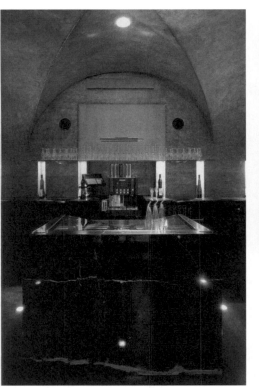

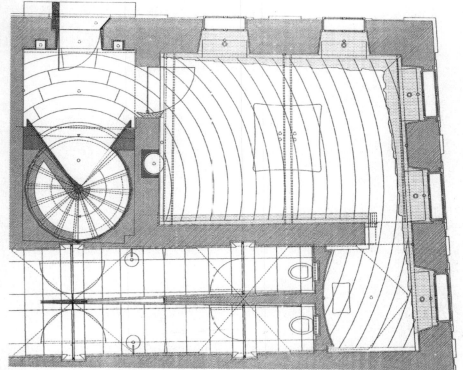

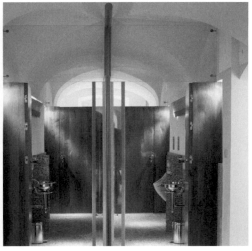

The *Zebra* gallery, which is located in one of the nineteenth-century buildings designed by the Croatian architect Joze Plecnik, exhibits furniture and glass objects by the artist Oskar Kogoj. A few metres away, the curious visitor descends four steps from street level to enter the *ZeBar* (a word play on Zebra), housed in the same building. The black marble floor, which contrasts with the golden ochre walls and the arched ceiling, makes clear that this bar is for creatures of the night. Small lights illuminate the wall niches, and floor lighting guides guests across the inky surface. The archaic quality of the interior is also apparent in the lavatories, though these are much lighter. Guests enter via a sort of forecourt whose old natural stone gives way, in the restrooms, to light Bianco Sardo granite which extends halfway up the walls behind stainless steel wash basins. Both lavatories are separated by a mirrored wall supported by a room-high stainless steel pillar – a Semper metaphor and an allusion to ancient housing. Walnut wood doors reinforce this 'ancient building' impression. Glass extends from the top of the cubicles to the arched ceiling, giving the lavatories a light and airy feel. An arcade outside the building modulates the incoming daylight.

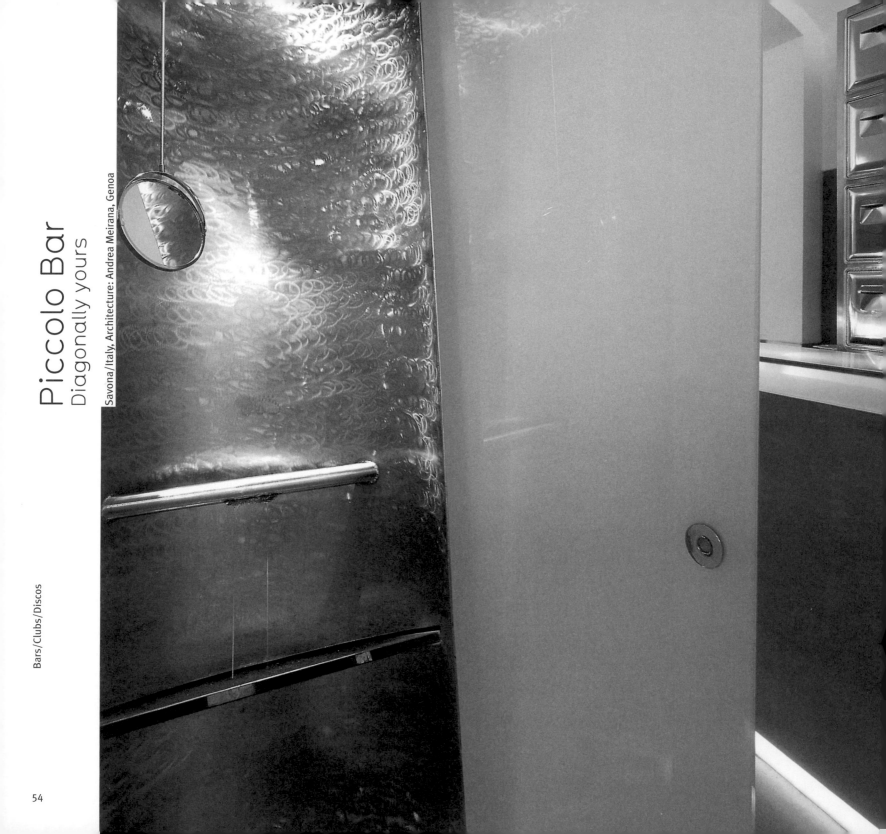

Piccolo Bar
Diagonally yours

Savona/Italy, Architecture: Andrea Meirana, Genoa

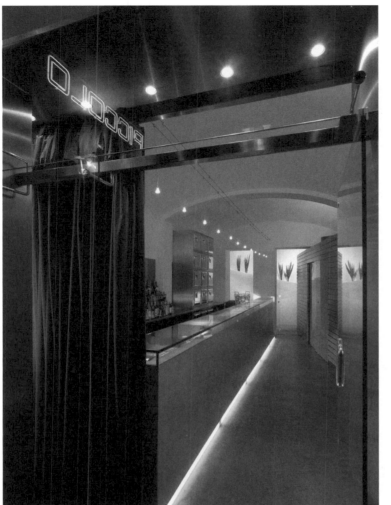

A heavy red velvet curtain parts at the entrance, affording a view of a narrow room intersected by a glass-topped bar. The floor and the front of the bar are made of polished concrete. What makes this space so interesting is a wall of horizontal, satinised, gray steel slats. Not quite reaching the ceiling, it runs diagonally across the room and separates off the washing areas and the toilets. The wide sliding doors in the slatted wall open onto a sharp-cornered washing area and have frosted glass panes that match the bevelled glass of the bar. In front of a curved steel wall, water – regulated by sensor technology – drips from a horizontal steel pipe onto a pitched pane of glass. Sparkling yet unassuming, it is reminiscent of a rock spring. The drain remains invisible. A floor lamp spotlights the scenery from below. A very impressive, economical solution.

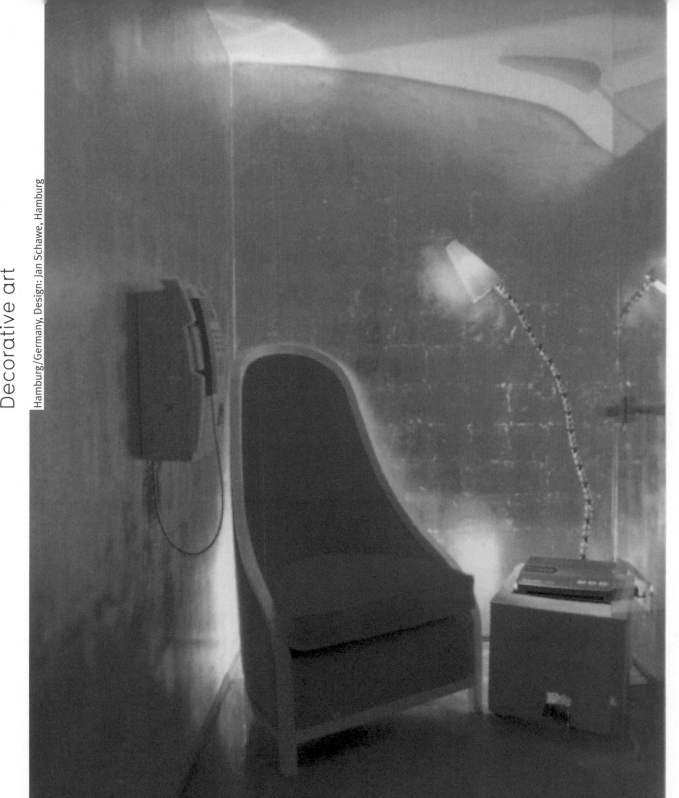

Bar Hamburg
Decorative art

Hamburg/Germany, Design: Jan Schawe, Hamburg

Bar Hamburg is housed in a stately nineteenth-century building near the *Alster* River and the *Schauspielhaus* theatre. This combination of bar, lounge and restaurant extends over two levels and has been designed as a stage-like bar landscape with a remarkable play of lights, ornamental wall objects and striking decorations. The overall impression is intensified by the 1930s leather armchairs in the lounge, a golden telephone box in the cellar and, not least, the toilet facilities: the small flat screens above the urinals, showing video art or special music clips, distract the gents from embarrassing small talk or sidelong glances. Otherwise the room has a rather bare look, perfectly in tune with masculine sobriety. The same is true of the washing area, where the small sinks and mirrors bear the word *Kopie* (copy). One of the toilets has been crafted into a decorative cubicle of light containing changing installations – male toilet-goers can gaze through a peephole in the glass wall. The women's room and washing area have warm colors and a more homey feel. Beige-brown walls separate the grooming niches from the washing areas, where a white ceramic basin on a dark wood counter creates the air of an elegant hotel room. This impression is heightened by the gentle light and by mirrors that cover the entire wall.

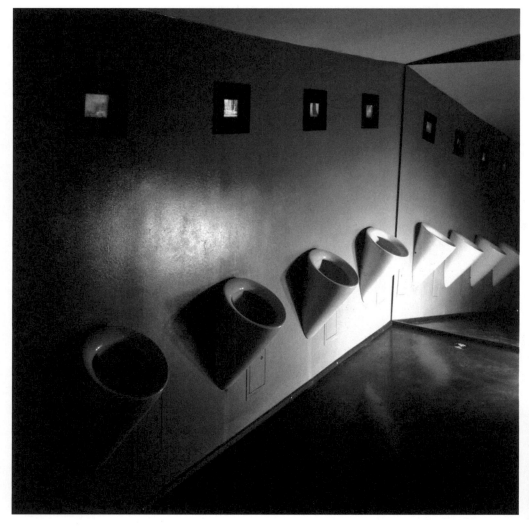

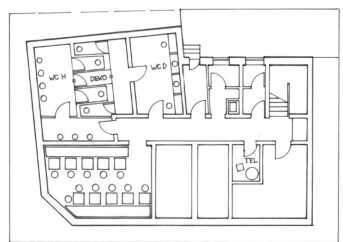

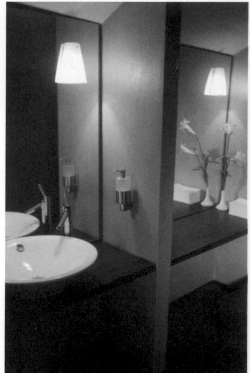

Supperclub
Islands of conversation

Amsterdam/Holland, Design: Concrete Architectural Associates, Amsterdam

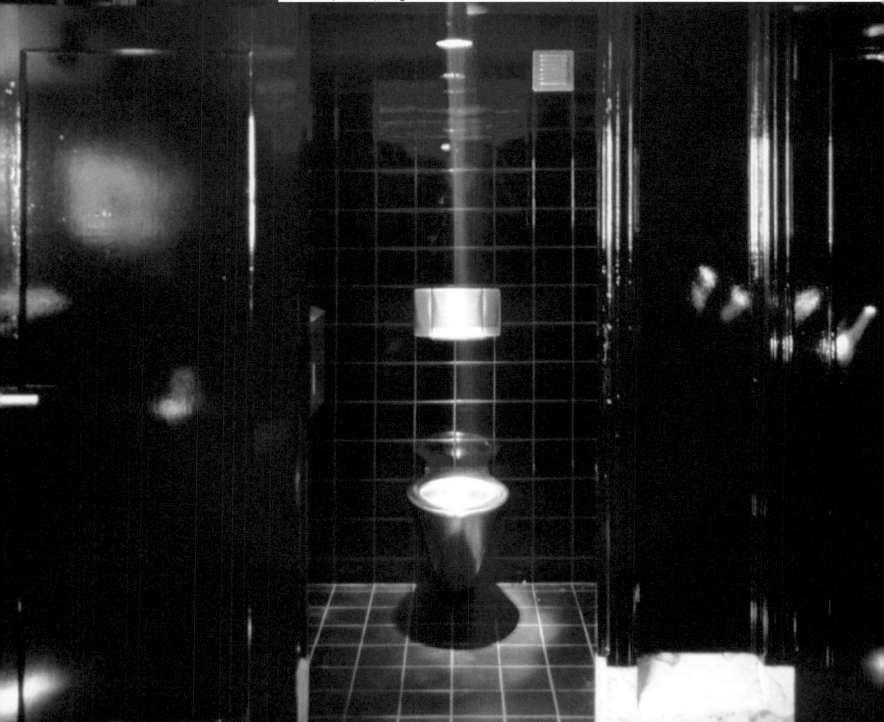

By many accounts, it was the *Supperclub* that first introduced lounge life to Amsterdam. It is a place of repose – a spacious, stylish establishment with exotic dishes and constantly changing presentational concepts. Club-goers can relax in four areas: la salle neige, le bar rouge, le salon coloré and les toilettes noires. In the white restaurant, diners – eating from silver trays – sit on white mattresses or Panton chairs in the middle of the room. The spatial atmosphere changes with the coloured light and projections. The red bar awakens memories of the neon craze of the 1960s, whilst the coloured lounge allows club members to escape reality in a private setting, enjoying chill-out tunes. The lavatories, which are marked 'homo' and 'hetero' instead of 'women' and 'men', are the club's most remarkable feature. Convinced that white would not be conducive to conversation, the designers executed the toilets in black to create genuine meeting places. Guests sit and chat on large rubber blocks, ignoring the occasional visitor to the urinals behind them. Instead of mirrors there are glowing bull's eye windows, through which guests can espy potential partners. The stainless wash basins and toilets, as well as the dramatic lighting, give these rooms their distinctive club character.

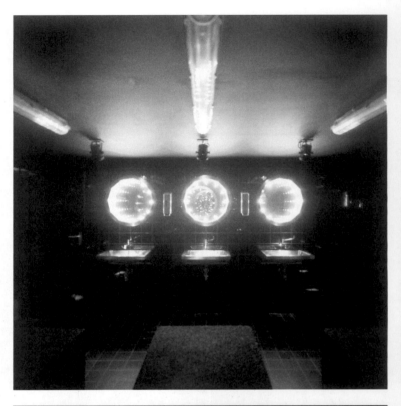

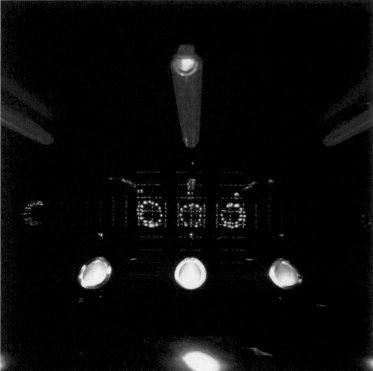

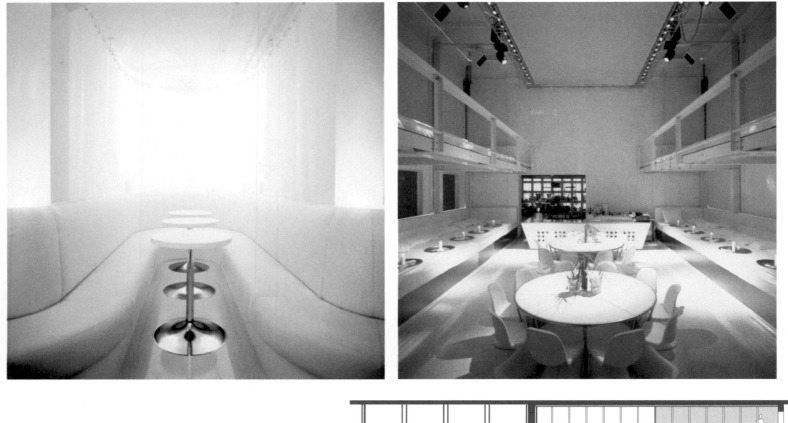

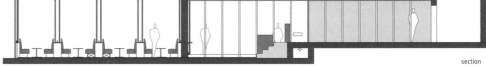

section

section

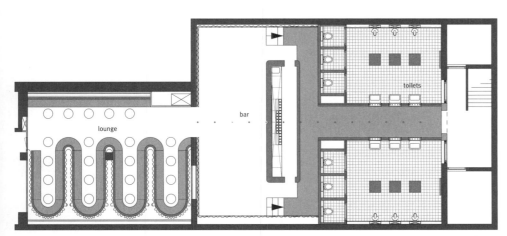

plan

Nasa Club
White and spacey

Copenhagen/Denmark, Design: Johannes Torpe, Copenhagen

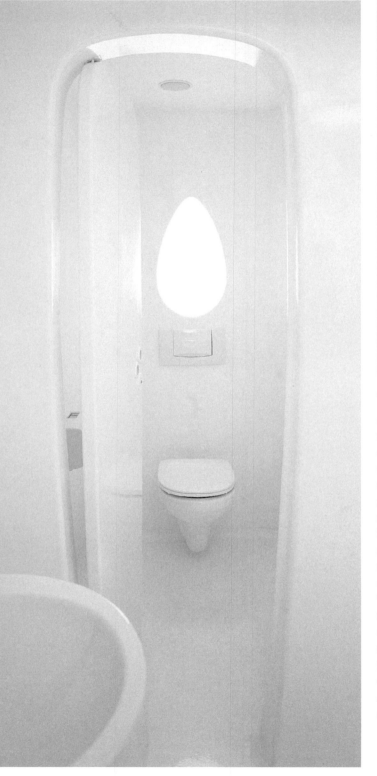

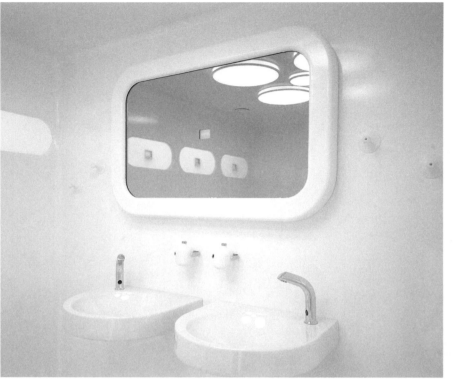

To visit this night club you have to be rich, famous, a model, or know someone who is. *Nasa* is the Copenhagen night club for the slightly older, creditworthy, jet-setting clientele, a 'members-only' establishment. The reach is international, the ambience exclusive and the service beyond reproach. A glass elevator 'beams' well-heeled guests up to the second floor, where the interior design has been inspired by 1960s sci-fi films and resembles a spaceship interior: rounded white shapes, oodles of plastic, indirect lighting, opal glass ceiling lamps, neon objects on the walls, and white leather benches. White Japanese carp swim in the aquarium in the reception area. The futuristic design has even been extended to the toilets, which feature soft spatial shapes as well as rounded door and mirror frames. Neon patterns on the room-wide mirrors over the wash basins resemble computer screen codes. The spatial shapes almost blur in the absolute whiteness of this exclusive spacey club.

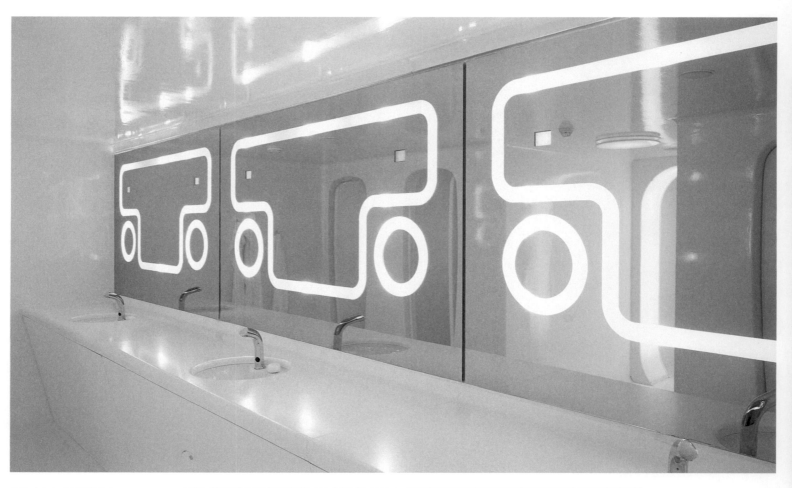

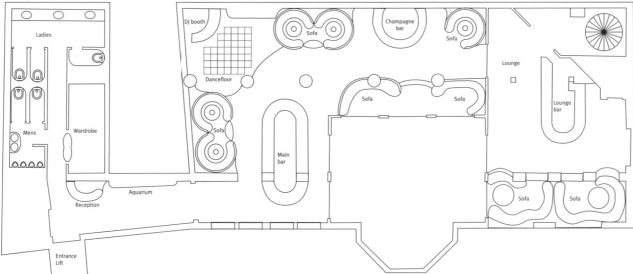

Ladies

Mens

Wardrobe

Reception

Aquarium

Entrance
Lift

Dj booth

Dancefloor

Sofa

Sofa

Main
bar

Champagne
bar

Sofa

Sofa

Sofa

Lounge

Lounge
bar

Sofa

Sofa

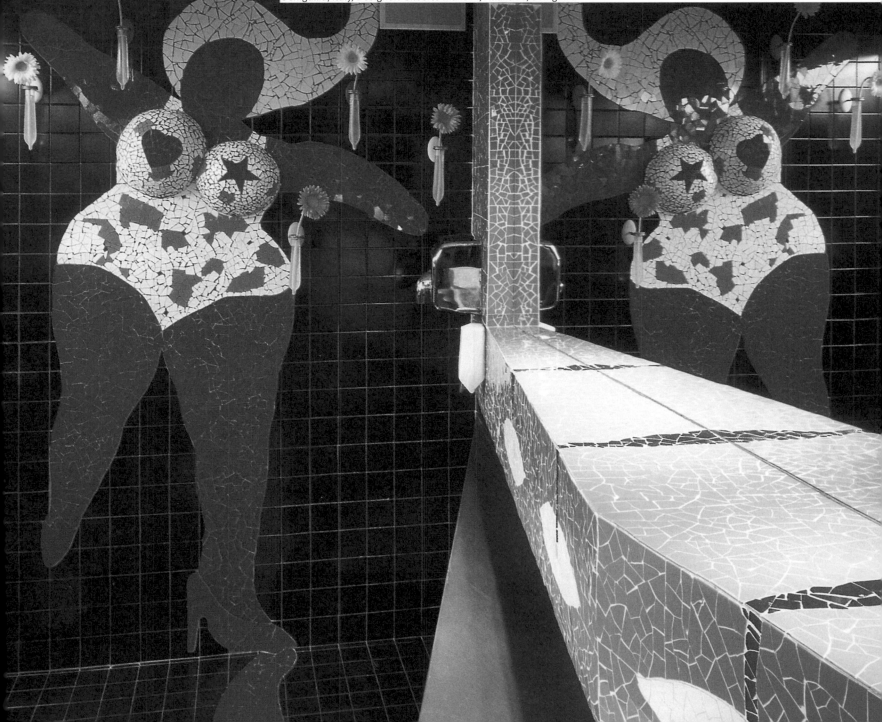

Mamamia
Joie de vivre

Senigallia/Italy, Designer: Gilberto Mancini, Atlantide, Senigallia

Mamamia is a popular 'alternative' music theatre on the city periphery that holds pop and rock concerts and small theatre productions. The owner regards joie de vivre and music as essential aspects of life, and he has incorporated them into the design of his lavatories. The fun starts at the wide lavatory doors: spiffy devil pictograms, taken from the club's logo, guide customers to the right room. In the women's washing area, square black tiles form the backdrop to an oversized 'Donna forever' wall decoration, a three-dimensional mosaic with vases made of condoms. The mirror is framed by irregularly shaped sculptural surfaces of coloured mosaic. Water, regulated by sensor technology, runs into an angular steel basin. Symbolically linking 'male' and 'female', a path of red tiles leads dramatically from the women's to the men's room, ending beneath a glaring light at the ceiling. The space here has a much more composed, rational feel – white tiles are used instead of black, and black-and-red mosaics lend the room a musical rhythm. Instead of broad mirrors to reflect masculine beauty, the men's room is decorated with mirror 'flames' for that last critical glance. A sensuous joie de vivre even in the loo.

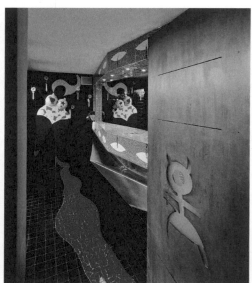

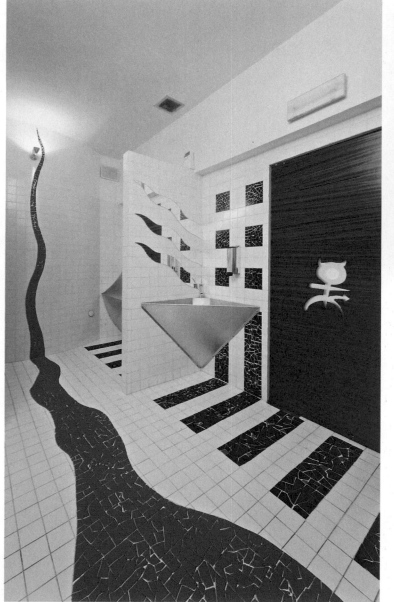

Fura
Industrial performance

Lonato/Italy, Architecture: Beppe Riboli Design, Crema

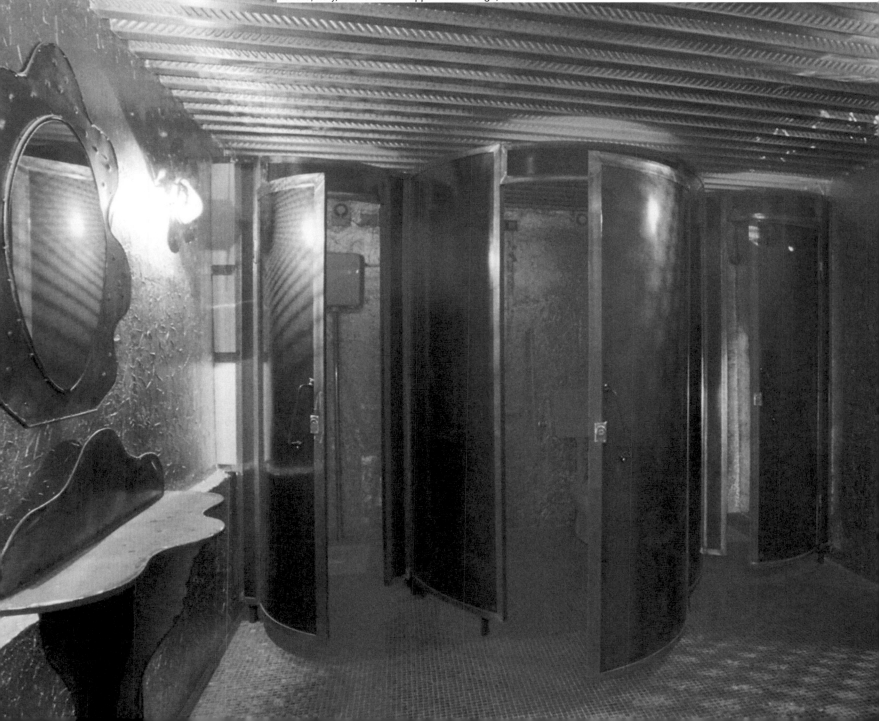

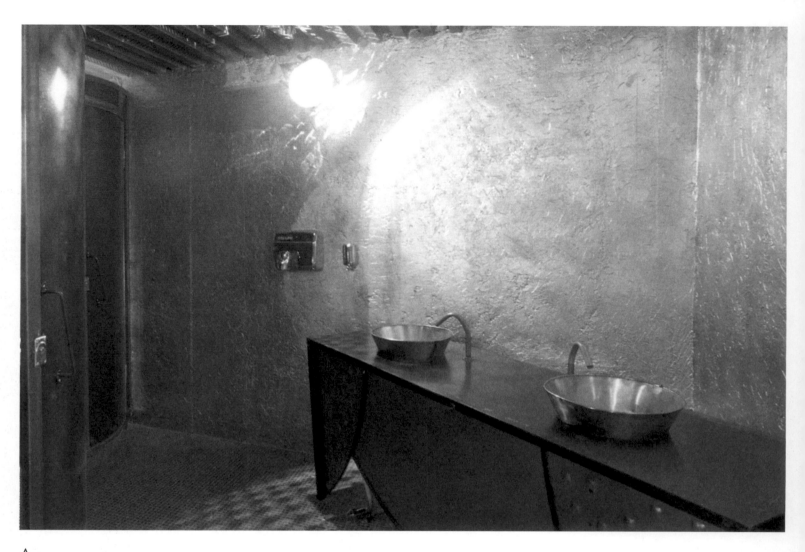

A large empty hall with a simple cement structure provides the unusual setting for this discotheque in Lonoato on Lake Garda. The technical equipment can conjure a sophisticated multimedia stage out of thin air. A 360° fabric projection screen is suspended over the dance floor, and 20-metre-long sequences of modern icons are displayed on the side walls. A complete stage set with traverses and spotlights supports the music shows and performances. Borrowing a few elements from the theatre, this industrial architecture has been transformed into a big stage: heavy blue velvet curtains cloak the entrance, and visitors are guided by lights set into the con- crete floor. The riveted steel furniture recalls ser- rated curtains. The strange production continues in the toilets. A floor of small mosaic tiles runs through the rooms, whose walls have been finished in rough plaster. Gleaming trapezoidal sheet on the ceiling reinforces their industrial character. All the instal- lations are made of steel. The cubicles consist of illuminated blue cylinders, and over the washstands hang what look like fabrics that have metamor- phosed into steel. Even the florally shaped mirror frames and shelves are steel. Industrial performance in all senses of the word.

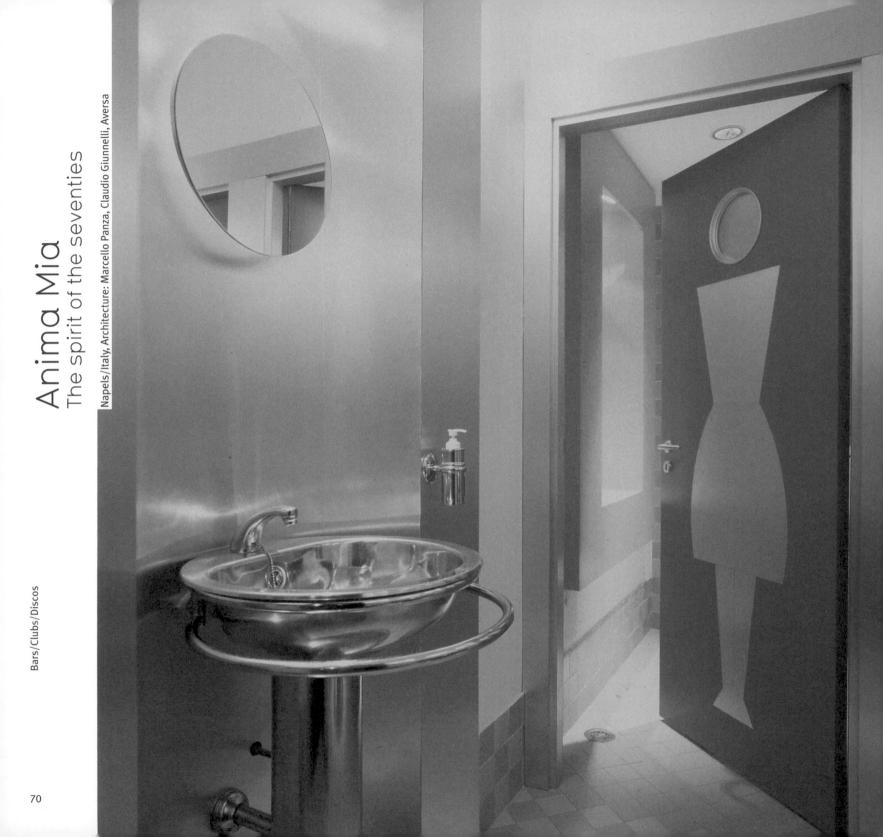

Anima Mia
The spirit of the seventies

Napels/Italy, Architecture: Marcello Panza, Claudio Giunnelli, Aversa

Bars/Clubs/Discos

70

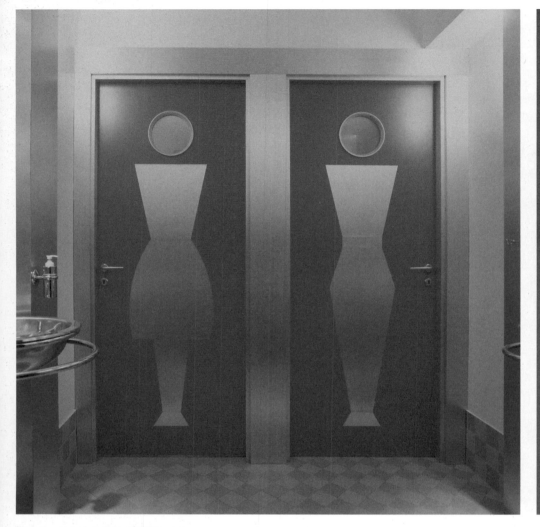

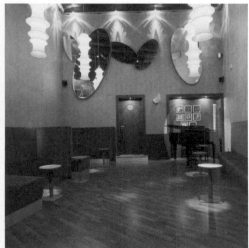

In the heart of Naples, this night club, as the name implies, evokes the spirit of the 1970s. Its unique design creates a piano bar mood while capturing the decade's raucous music. It makes use of the plastics, imitation wood and wallpaper that were innovations at the time. Bruni Munari's Falkland ceiling lamps are multiplied in the room's oval mirrors, which are playfully arranged remakes of the classic salon looking glass. The colours and entire spatial mood reveal the many ways the creators used modern means to reformulate the classic theme of 'counter-design', associated with both a quest for peace and a subversion of middle-class tastes. The toilets also capture this mood. A chequered pattern of green and yellow tiles, typical of the period, divides at the door to become green on the floor of the ladies' and yellow in the men's room. The doors bear stark, oversized pictograms. In contrast, the stainless steel sinks, toilets and framed wall niches, which give the restrooms their special flair, are very much products of our age.

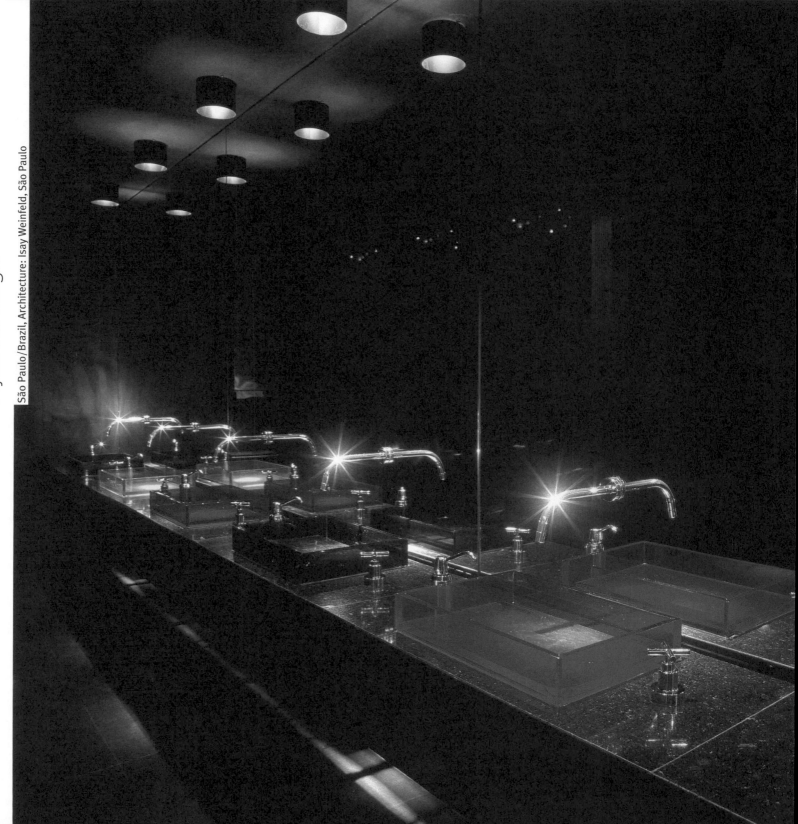

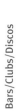
Disco
Mystical magic

São Paulo/Brazil, Architecture: Isay Weinfeld, São Paulo

Night-clubbers indulge the sensuous pleasures of light and music. They are hardly aware of the space around them. Case in point: *Disco* in São Paulo. The designer wanted to be 'elegant and daring', from the entrance right down to the lavatories. And he has certainly succeeded. The walls and ceiling of the entrance tunnel are covered with coloured glass mosaic and punctuated by points of light. At the end of the corridor, the word *Disco* beams in orange neon writing that is reflected in the floor and walls. Since all the inside rooms are black, guests can hardly make out the interior. Light, acrylic glass and colour are used for orientation and presentation. The attention-grabber behind the long bar is a light picture created by the Campana brothers from coloured plastic threads. The carpets, leather armchairs and plastic furniture are all done in black, with acrylic glass boxes and coloured lounge chairs aglow between them. The toilets also boast a black elegance. The floors and washstands are made of granilite, an artificial stone, and corrugated black sheeting encloses the cubicles. Even the sanitary appliances are of black ceramic. The gleaming chromed fittings and wash basins of transparent coloured acrylic glass are dramatically illuminated by way of contrast.

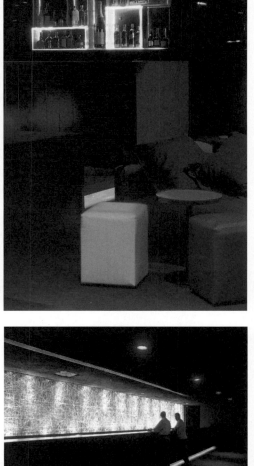

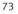

Splendid Roman latrines

The Romans were fond of spending time together. Consequently, from early 200 BC onwards, they constructed large latrines that held twenty-five to eighty people in splendid works of architecture. The small distance between users (50-60 cm at most) encouraged social contact. As these large latrines were located in a colonnaded courtyard, they received abundant light and were well ventilated. Excrement was washed away by the water flowing underneath. In many cases, the latrines were also connected to thermal springs. The furnishings were quite luxurious: the benches were made of marble slabs, the pipes providing water for cleaning the floor ran beneath the ground, and the floors were decorated with mosaic. Mural frescos and fountains were a delight to eye and ear alike. As the regular visitors to these splendid latrines were members of the well-situated mercantile class, the latrines were generally located close to the bustling centres of activity: the forums and the agora. 'The Roman latrine was an interface between the private and public spheres, where desire to regulate people's personal lives encountered the need for interpersonal contact.'
Richard Neudecker: Die Pracht der Latrine.
Munich 1994

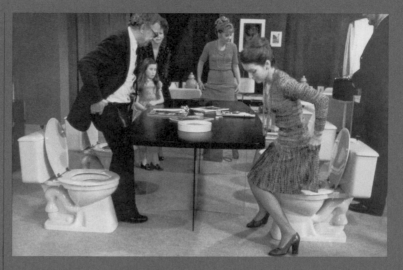

'The Phantom of Liberty', a film by Luis Buñuel, 1974 – a dinner party on toilet seats

Inspired by the cryptically ironic slogan 'Long live chains! Down with liberty!' Luis Buñuel created an ingenious puzzle with his 1974 film 'The Phantom of Liberty', in which he pieces together images of a topsy-turvy world. Images from the nineteenth century are combined with images from the present; a nurse encounters monks who play poker for pictures of the saints; dinner party guests sit on toilets; an animal-lover massacres harmless passers-by; a police prefect is arrested for defiling graves. As in his other films, Bunuel directs his sarcastic humour against the bourgeois world and its obsessive procedures, which he interprets in a manner that is both alarming and funny. He turns the bourgeois world on its head and derides it at the same time. This is an almost surrealist film full of gloomy symbolism and disquieting riddles.

Cloaca Maxima

This is not the name of a goddess (though Cloaca possibly stems from Cluacina – the Purifier) but that of the oldest surviving sewage system in Rome. As early as the sixth century BC, the Etruscans ran canals through the marshy Forum Romanum and built the cloaca maxima out of mighty blocks of tuff, subsequently adding a barrel vault.

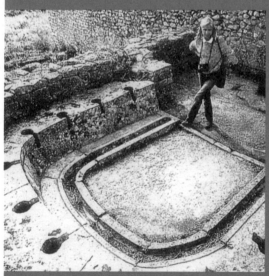

A multi-seater Roman latrine in Dougga

Xinox
Washrooms and Sanitary Systems

Design: Berger + Stahl, Basel/Switzerland

More and more architects and planners are seeking to transform washrooms into refreshing oases and attractively designed places where people can relax and feel comfortable. Franke supplies the products that will make your design dreams come true:

The Xinox range is a diversified, adaptable collection of washroom appliances and fittings specially designed for top restaurants, opera houses and international hotels. Whenever people place high demands on hygiene, comfort and style, Xinox is the right choice.

Franke GmbH
Oberer Aichdamm 52
A-6971 Hard
Austria
Phone 0043 5574 6735 0
Fax 0043 5574 6735 220
www.franke-wss.com

List of works reproduced

Conran & Partners
22 Shad Thames
GB-London SEI 2YU
www.conranandpartners.com

Consuline
Francesco Iannone
Via Valvassori Peroni 47/A
I-20133 Milano
www.consuline.com

Créations Chérif
13 Avenue Daumesnil
F-75012 Paris
www.creations-cherif.com

Xavier Denamour
Restaurant Cafeine
30 Rue Vieille du Temple
F-75004 Paris
www.cafeine.com

Nenad Fabijanic
Arhitektonski Fakultet
Kaciceva 26
HR-10 000 Zagreb

Fumita Design Office Inc.
Fukuda Bldg. 1F+B1F, 2-18-2,
Minamiaoyama, Minato-ku
J-Tokyo 107-0062
www.fumitadesign.com

Manuelle Gautrand Architects
36, Boulevard de la Bastille
F-75012 Paris
www.manuelle-gautrand.com

Jentsch Architekten
Gubener Str. 47
D-10243 Berlin

Gilberto Mancini Architetto
Atlantide Atelier di Architettura
Via torre 148, Montignano
I-60019 Senigallia

Andrea Meirana
Via Dante 2/158
I-16121 Genova

Uwe Mertens + Partner GbR
Buchener Str. 31
D-83646 Bad Tölz

Simone Micheli
Studio d'Architettura
Via Novelli 43
I-50135 Firenze
www.simonemicheli.com

Fabio Novembre
Via Mecenate 76
I-20138 Milano
www.novembre.it

Marcello Panza
Studiominimo
Via Drengot 36
I-81031 Aversa

RHE
Richard Hywel Evans Architecture &
Design Ltd.
Great Titchfield House
14-18 Great Tichtfield Street
GB-London W1W 8BD
www.rhe.uk.com

Beppe Riboli Design
Via Benzoni 11
I-26013 Crema
www.bepperibcli.com

RSP-Architekten
von Rudloff, Seiffert & Partner
Antwerpener Str. 6-12
D-50672 Köln
www.rsp-architekten.de

Erich Sammer
Mollardgasse 70a/9
A-1060 Wien

Jan Shawe
Bar Hamburg
Rautenbergstr. 6-8
D-20099 Hamburg
www.welovedesign.net

Endo Shuhei Architect Institute
Domus AOI 5F 5-15-11
Nishitenma Kita-ku
J-Osaka 530-0047

Stilbruch United Designers
Michael Müller
Emser Str. 54-56
D-65195 Wiesbaden
www.stilbruch-united-designers.de

Studio Philippe Starck
18/20 Rue du Faubourg du Temple
F-75011 Paris
www.philippe.starck.com

Tihany Design
135 West 27th Street, 9th floor
USA-New York, N.Y. 10001
www.tihanydesign.com

Johannes Torpe Studios ApS
Skoubogade 1,1
DK-1158 Copenhagen K
www.johannestorpe.com

Matteo Thun
Via Appiani 9
I-20121 Milano
www.matteothun.com

Stephen Varaday Architecture
14 Lackey Street
AUS-St. Peters NSW 2044
www.stephenvaraday.com

Vierkötter & Co GmbH
Hans-Böckler-Str. 10
D-40764 Langenfeld
www.architekten-vierkoetter.de

Isay Weinfeld
Rua Andre Fernando 175
BR-São Paulo SP
www.isayweinfeld.com

Bibliography

Bebel, August: Aus meinem Leben.
Bonn 1997

Blume, Jacob: Von Donnerbalken und innerer Ein-
kehr, eine Klo-Kulturgeschichte.
Göttingen 2002

Brecht, Bertolt: Collected Plays.
London 1970

Enzensberger, Christian: Größter Versuch über den
Schmutz.
München 1968

Giesen, Rolf/ Weiß, Klaus Dieter: Das Klo – Schmutz
wird durch Poesie erst schön.
Berlin 2000

Greed, Clara: Inclusive Urban Design: Public Toilets.
Amsterdam 2003

Jun'Ichiro, Tanizaki: In Praise of Shadows.
Vermont 1977

Kiechle-Klemt, Erika/Sünwoldt, Sabine: Anrüchig
– Bedürfnis-Anstalten in der Großstadt.
München 1990

Kira, Alexander: The Bathroom.
New York 1976

Kundera, Milan: The Unbearable Lightness of Being.
New York 1984

Lindigkeit, Lars/Schabenberger, Stefan: Spülen nicht
vergessen – Das Toilettenbuch.
Berlin 2003

Neudecker, Richard: Die Pracht der Latrine – Zum
Wandel öffentlicher Bedürfnisanstalten in der kaiser-
lichen Stadt.
München 1994

Pieper, Werner (Hrsg.): Das Scheiss-Buch – Entste-
hung, Nutzung, Entsorgung menschlicher Fäkalien.
Löhrbach 1987

Ryn, Sim v.d.: Mach Gold draus. (quoted by Werner
Pieper)
Freier Verlag

Schrader, Mila: Plumpsklo, Abort, Stilles Örtchen.
Suderburg 2003

Vetten, Horst: Über das Klo – ein Thema, auf das
jeder täglich kommt.
Berlin 1983

Wright, Lawrence: Clean and Decent.
New York 1960

Architects' addresses

Archea
Studio d'Architettura
Lungarno Benvenuto Cellini 13
I-50123 Firenze
www.archea.it

bauArt
Planung & Bau GmbH
Rampengasse Bogen 282
A-1190 Wien
www.bauart.co.at

Mathis Barz
Neustiftgasse 41
A-1070 Wien
www.barz.at

Antonello Boschi
Via Colombo 22
I-58022 Follonica

CAM
Carmen Amelia Munoz de Frank
Langenfelder Str. 93
D-22769 Hamburg

Concrete Architectural Associates
Rozengracht 133 III
NL-1016 LV Amsterdam
www.concrete.archined.nl

Toilet guides

Websites

Greater mobility and a desire for comfortable toilets with good service have led to the publication of countless toilet guides that are structured like travel guides. The guides contain maps and information on toilets: opening times, furnishings and fittings, cost, whether they are suitable for disabled people, and whether they include nappy-changing areas and have acoustic signals for the blind, etc. These town toilet guides are mainly intended for people who want to know where they can find the nearest toilet. Such information is particularly important for people suffering from incontinence, for the disabled and their carers, and for families with children. The guides are also an excellent source of information for people planning private and business trips.

Internet toilet guides are much livelier because they are continually updated in response to user feedback. They also provide information on the maintenance and condition of the toilets listed – ranking them accordingly – and on their design.

A selection of toilet guides:

Access in London – covers all aspects of public life (Gordon Couch, Bloomsbury 2003).

The Wiener Toiletten-Stadtführer (Medizinische Gesellschaft für Inkontinenzhilfe, Innsbruck 2002).

Stadtführer für alle Fälle – covers public toilets in Berlin and Hamburg (J. Haspel, R. Elwers, T. Schröder, Hamburg 2002).

Stadtführer für Notfälle – Hamburg and its public toilets (A. Küpper, K. Dugge, Hamburg 2002).

www.toiletmap.gov.au
The National Public Toilet Map – a toilet guide to Australia.

www.asahi-net.or.jp/~AD8Y-HYS/index_e.htm
Toilet Map of Tokyo – a private site containing extensive tests and interesting information.

www.thebathroomdiaries.com
Contains 8,000 tests from one hundred countries with detailed assessments (including toilet design). It selects certain toilets and classes them as 'the world's best'.

www.bugeurope.com/destinations
At the moment, this site only offers information on the location of public toilets in France and what they charge.

www.worldtoilet.org
The World Toilet Association provides detailed information on products, design and technology for planners and manufacturers.

For thirty years, Singapore has boasted one of the world's loveliest zoos. The animals have space to move about freely and live as they would in their natural habitats. The 28-hecatre zoo is home to more than 420 species and 3,600 animals, yet the white rhinoceros and the white Bengali tiger are not its only attractions: it has the cleanest and most creatively designed toilets on the entire island. Reflecting the natural landscape and the zoo's open concept, they also offer guests ample space for rest and recuperation. Waterfalls, small ponds and lush vegetation create a sense of openness, as well as a pleasant, intimate atmosphere. They are, at the same time, the central theme of the design, which betrays Balinese influences. Water and vegetation make visitors feel as if they are in the wilderness, and the water surfaces close to the toilets keep mosquitoes at bay. Comfort and cleanliness are writ large: there are not only lavatories for the handicapped, but also smaller wash basins and WCs for children. These toilets have received the 'The Cleanest Toilet Award' several times from the Singapore Ministry of the Environment.

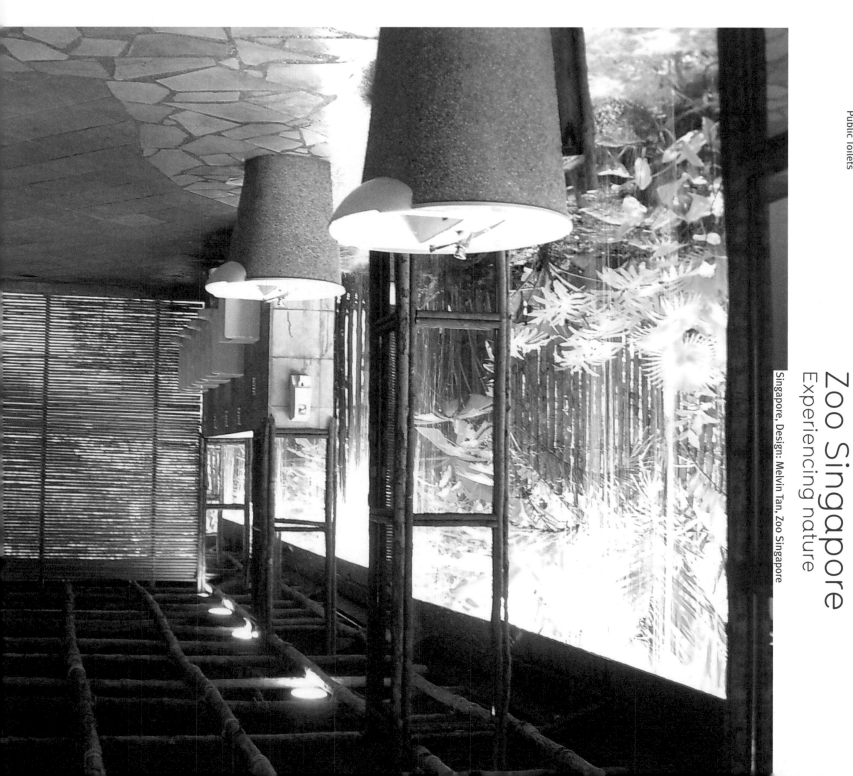

Zoo Singapore
Experiencing nature

Singapore, Design: Melvin Tan, Zoo Singapore

There is an rambling, man-made park in Hyogo about an hour from Osaka by bullet train. A unusual pavilion in the midst of the hilly landscape catches the eye. It has the form of a wide uncoiling ribbon whose twists and turns make for spectacular architecture (called 'springtecture' by the architect). The entire integument of the building is formed by a single material – corrugated metal sheeting. Inside there are three areas: a toilet for men, one for women, and a service area for janitors. Complying with Japanese toilet philosophy, the structure offers comfort, openness and security. Three entrances take the form of a passageway and provide easy access to the interior. Together with light partition walls that are open at top, the corrugated sheeting creates the desired seclusion. The interior design is defined by the spiral of corrugated sheet, which links the interior and exterior in a striking interplay of effects. The structure is at once industrial and natural, light and dark, closed and open – the matrix of a new Japanese architecture and toilet culture.

Springtecture in the Park
A spiral of corrugated sheeting

Hyogo/Japan, Architecture: Shuhei Endo Architect Institute, Osaka

COUPE TRANSVERSALLE FACADE ARRIERE

FACADE ARRIERE

In contrast to most toll stations with their unimpassioned architecture, those on the A16 motorway were designed to engage the region, which is home to a large number of gothic cathedrals with magnificent stained-glass windows. This special characteristic was integrated into a kind of architecture that makes the toll stations a readily identifiable component of the motorway. Each station has a pitched roof of hardened laminated glass that adopts features of the landscape and at the same time heals the wounds inflicted by road construction. And each of the five toll stations features a colour from the region, visually linking it to the surrounding cornfields, poppy flowers, forests, seaside landscapes, and dark fields. The small toilet buildings are located right beside the toll station and consist of two bulbous, polyester-resin containers which are flattened on top and adjoined to a concrete slab containing the sanitary technology. The glass roof of the toll station continues over the toilet buildings. Joined in this manner, the station and the sanitary facilities create a cheerful ensemble that travellers won't easily forget.

Toll Stations
Coloured cubes

Northern France/A 16, Architecture: Manuelle Gautrand Architects, Paris

In Dubrovnik's old harbour district, a fourteenth-century city wall and four gates enclose a homogenous building complex with public functions. Public toilets were erected in the passageway between the city wall and the old port authority. The facility is not so much a building as a thick wall that runs to a point on one side. With its monumental air and sculptural indentations, it has the air of an Egyptian temple. A fountain has been built into its outer wall in the tradition of public springs, inviting visitors to freshen up on a walk along the city walls. The narrow lavatory – 1.70 m wide and 12.50 m long – is clad in a regional stone, a polished dolit, and ends in a sharp edge with an amusing carved-out lip that triggers a variety of associations. Inside there are two cubicles for women and one for men, all equipped with squat toilets and steel wash basins. The walls and floors are of a black Angolan stone that radiates a pleasant coolness in this hot city.

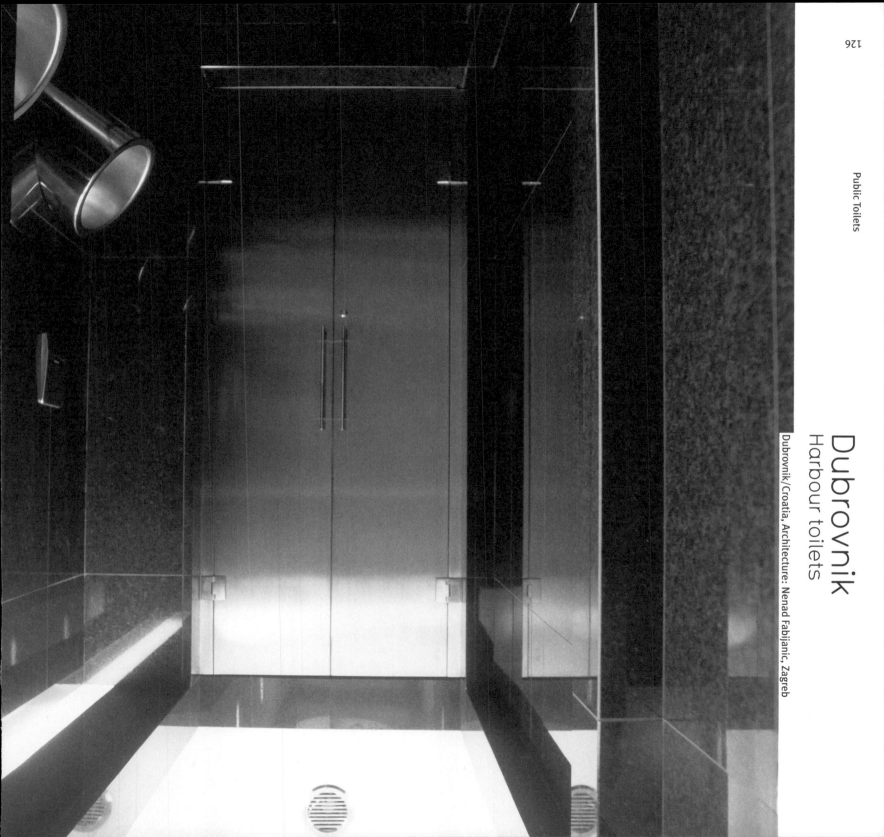

Public Toilets

Dubrovnik
Harbour toilets

Dubrovnik/Croatia, Architecture: Nenad Fabijanic, Zagreb

Public Toilets

by Ute Helmbold, Essen

Whether as traffic symbols, airport pictograms or screen icons, images have assumed a vital role: by providing information and orientation without words, they are able to transcend linguistic boundaries. Our global village would not be possible without visual language.

The toilet symbol is surely one of the best-known and oldest signs in the world. It comes in every size, shape and (more or less deliberately designed) form: we are shown the way to the toilet by austere, systematized pictograms, by freely rendered, graphically reduced signs, and even by painted pictures. Other depictions have original and unconventional aspirations and are the product of very idiosyncratic interpretations. We also encounter symbols that seek to amuse us with folksy and/or comical designs.

All the symbols for 'male' and 'female' say more than they actually intend. They are an expression of the society in which they emerge and for which they have been made. They are telltale artifacts: they communicate social values, and they embody customs and conventionalized attitudes. What's more, they give away many an artistic vanity.

It is the human body that makes this symbol both intriguing and vulnerable, since everyone can identify with the representation of a human being. Everyone is an expert, even non-designers.

There is hardly any other symbol on which so many anonymous designers have left their mark – the generic toilet pictograms challenge us to do just this and are frequently added to, amended, scratched and painted over. Even so: no other pictogram has the same capacity to liberate itself from its symbolism while still remaining intelligible.

The examples shown here document the diverse forms of toilet symbols, exploring modes of conventionalized representation, questioning visual comprehensibility, and showing an entirely individual interpretation of everyday iconography.

Ute Helmbold teaches illustration at the University of Visual Arts in Braunschweig. This text is from her book project 'Ikonographie des Alltags' ['Iconography of Everyday Life'].

Tanizaki Jun'ichiro – 'In Praise of Shadows', 1933

Tanizaki Jun'ichiro is one of the great Japanese authors of the twentieth century. In his small volume *In Praise of Shadows*, he describes Japanese aesthetics in conflict with an encroaching Western civilisation.

'Every time I am shown to an old, dimly lit, and I would add, impeccably clean toilet in a Nara or Kyoto temple, I am impressed with the singular virtues of Japanese architecture. The parlor may have its charms, but the Japanese toilet truly is a place of spiritual repose. It always stands apart from the main building, at the end of a corridor, in a grove fragrant with leaves and moss. No words can describe that sensation as one sits in the dim light, basking in the faint glow reflected from the shoji, lost in meditation or gazing out at the garden. (...) And surely there could be not better place to savor this pleasure than a Japanese toilet where, surrounded by tranquil walls and finely grained wood, one looks out upon blue skies and green leaves. As I have said there are certain prerequisites: a degree of dimness, absolute cleanliness, and quiet so complete one can hear the hum of a mosquito. I love to listen from such a toilet to the sound of softly falling rain. (...) And the toilet is the perfect place to listen to the chirping of insects or the song of the birds, to view the moon, or to enjoy any of those poignant moments that mark the change of the season. Here, I suspect, is where haiku poets over the ages have come by a great many of

their ideas. Indeed one could with some justice claim that of all the elements of Japanese architecture, the toilet is the most aesthetic.'
Translated by Thomas J. Harper and Edward G. Seidensticker, © 1977 by Leete's Island Books, Inc.

The Japanese Toilet – from nature to high-tech

As in other Asian countries, outhouses used to be common in Japan, particularly in rural areas. These privies are described in the work of the American Edward Morse, who lived in Japan during the nineteenth century: 'In the country the privy is usually a little box-like affair removed from the house, the entrance closed half way up by a swinging door. In the city house of the better class it was at one corner of the house, usually at the end of the veranda.' According to Morse, the privy generally consisted of two compartments, the first of which contained a wooden or porcelain urinal. This was called an 'asagoa' (morning glory) because it supposedly resembled that flower's blossom. The wooden urinals contained spruce branches that were replaced at regular intervals. Morse adds: 'Straw sandals or wooden clogs are often provided to be worn in this place.'

The toilet was mostly a squatter, that is, an elongated oval basin that was either set into the floor or stood on a base. Many public toilets are still based on this design today, with the front of the toilet basin forming a kind of hat. Users squat over the basin in a manner rather uncomfortable for non-Asians; however, the toilet is very hygienic since users do not touch any surfaces with their bodies. Cleanliness and hygiene play a major role in Japanese life, and the religious tradition of shintos places special emphasis on both physical and spiritual purity. Japanese sociologists regard the toilet as symbolising the purging of life's impurities, but other observers have pointed out that in an overpopulated country such as Japan, the toilet is perhaps the only place where a person can have a few minutes' peace and quiet. Toilets are thus equivalent to the car in America.

An old Japanese squat toilet

High-tech Japanese toilets today

The contrast couldn't be more striking. The old culture of privies in the great outdoors has been replaced by ingenious high-tech toilets that are talking points around the world.

Both sides of the toilet bowl are fitted with control panels with buttons and displays. You can adjust the toilet to your personal needs, and even warm the seat with the press of a button. Toilet paper is no longer needed. After doing your business, your backside is cleaned with great precision and thoroughness by a jet of warm water, before being air-dried. A sensor flushes the toilet. All the while the pleasant gurgle of wild brooks and the twitter of birds conceal any noises you happen to make. Additional features include an automatic room

deodoriser, toilet seats that lift automatically, and a height-adjustable seat that can even be tilted to make it easier for the elderly to dismount.

In the future the smallest room will even be hooked up to the Internet – the toilet will weigh you, take your blood pressure and pulse, measure your blood sugar and protein levels, and then transmit the data directly to your doctor via the World Wide Web.

And for those readers who might think that the female urinal was invented in Europe in the 1990s, please take note: Toto, a Japanese toilet maker, marketed a ladies' urinal between 1951 and 1968, producing several hundred units. However, 'women just didn't like to use them,' explains Toto's planning director.

A toilet with a high-tech seat

This late nineteenth-century factory building, an example of traditional brick architecture, has been brought back to life with a new interior and given a new purpose. A flexible system of furnishings and state-of-the-art technology make it possible to stage a wide range of events here: from concerts to TV shows, from company functions to festive balls. Five fully equipped bars and a 220-square-metre kitchen are designed to cater for up to 4,000 people.

In both scale and design, the toilets complement the size of the building and the great diversity of events staged here. The black-and-white wall tiles give the washing area in particular a very homely feel, setting it off from the toilets proper, which are very functional in design, with stainless steel urinal walls, matt-glass doors for the WC cubicles and white sanitary ware. Providing a contrast, the large washing area is decorated with oak shelves, above which there are large mirrors for those who feel the need to take one last critical look. The waste bins and the towel dispensers are contained in a room-high column. A white, perfectly round 'wash fountain' in the centre provides a focal point where people can gather and chat, making this a popular social area for women and men alike.

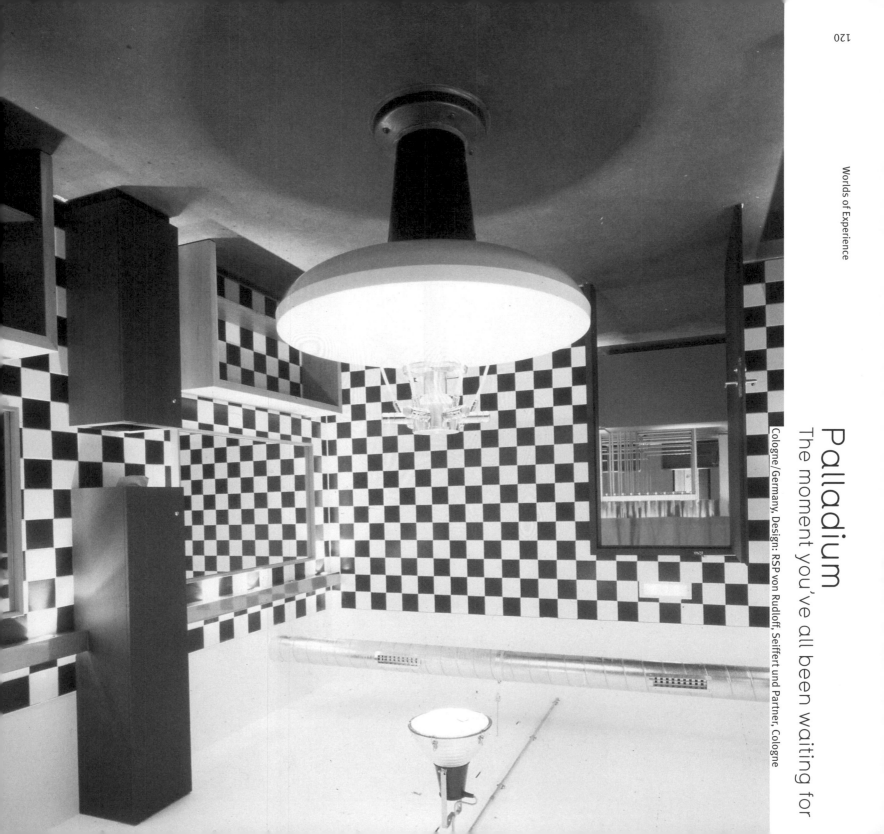

Palladium
The moment you've all been waiting for

Cologne/Germany, Design: RSP von Rudloff, Seiffert und Partner, Cologne

This former industrial building has been converted into an amusement centre covering 5,400 square metres. It contains a theatre, an ice-skating rink, a discotheque, a game room, cafés and restaurants. With the complex structure of a town, it allows visitors to stroll around, constantly discovering and experiencing new things as they go. Watching one minute, participating the next, visitors find themselves in a world that has much to offer in terms of design too: stairs, catwalks, glass floors, and a perforated steel façade which, when all is dark, metamorphoses into a light sculpture that is re-flected in the water basins. In the theatre auditorium – to the left and right of the stage – there are two snail-shaped bars, which double as stairs leading down to the toilets below. Here, too, the ambience is magnificent. The grey marble washstands and the surrounding stainless steel wall sections continue into a round room subdivided by back-lit glass urinal walls. To complete the effect, the toilets, which are situated next to the discotheque, are made of red marble and have a broad, back-lit glass urinal wall over which water ceaselessly flows. High-end entertainment – even in the toilets.

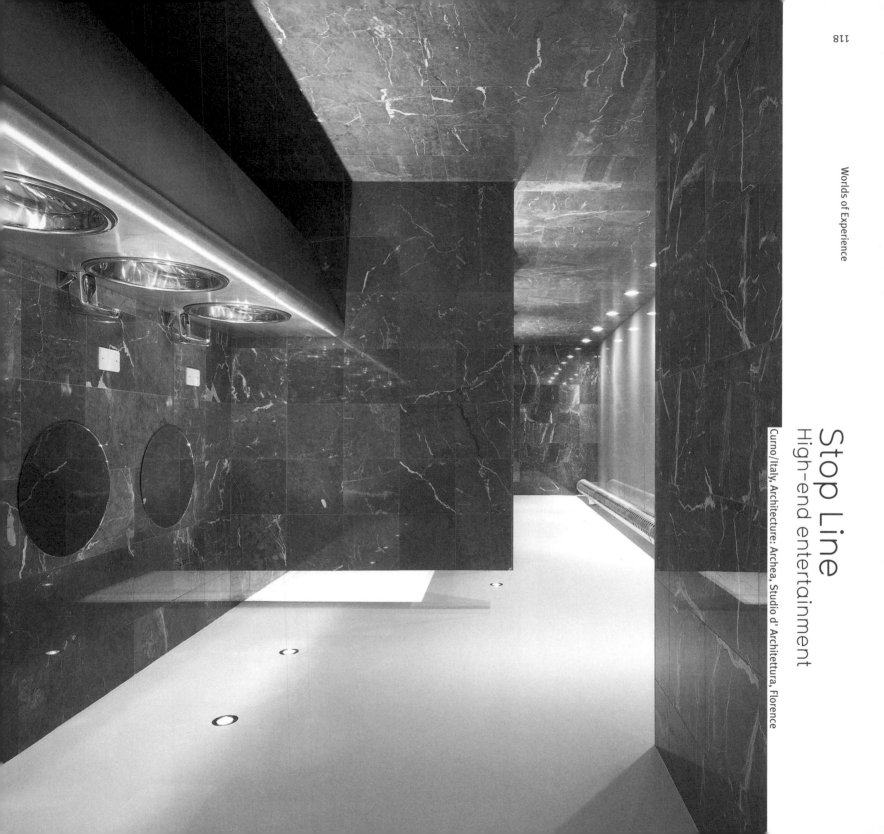

Worlds of Experience

Stop Line
High-end entertainment

Curno/Italy, Architecture: Archea, Studio d' Architettura, Florence

Buddy – the Musical was a great hit for many years. It not only revived the spirit but also the music of the 1950s, restating the truth in the line: 'Rock 'n' roll will never die'. This theatre was intended to recreate not so much the atmosphere of the 1950s, as to convey to audiences the esprit of such establishments, their shows and the energy that reverberates throughout these buildings. With this in mind, the designer extended the theatre theme to the toilets as well. Like a dramatic stage setting, stylised outlines of a man are set out in a line before the urinals in the men's toilets. The dark toilet is cast as a stage set, with shadow and illumination used to dramatic effect. The light only switches on when someone enters the urinal area. Mirror-clad metal walls separate the urinals. The ladies' toilets are composed of corrugated sheet metal with solid wood armrests on each side to keep contact to a minimum. Here, the mis en scène is concentrated on the glass doors, which are transparent in appearance only.

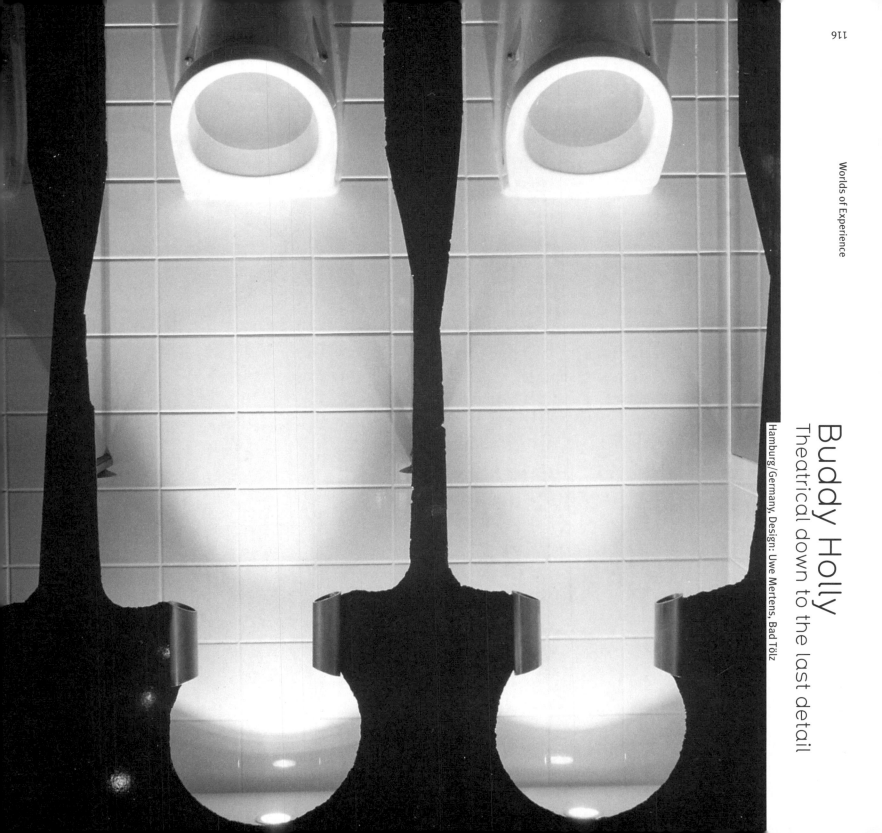

Buddy Holly
Theatrical down to the last detail

Hamburg/Germany, Design: Uwe Mertens, Bad Tölz

For its centenary, the Swarovski group, which manufactures crystal jewellery and accessories, commissioned multi-media artist André Heller to present his vision of the future in the form of a fairytale world. The result was the Crystal Worlds in Wattens (where the company was founded) near Innsbruck. A water-spouting giant, covered in vegetation, guards over the Chamber of Wonder and other subterranean realms of experience, which are not only clad with crystals but also given a new, mysterious dimension by the artworks, 3-D projections, and video-installations. In addition, a gallery, cafés, the Crystal Worlds shop, as well as areas for concerts and events offer outside companies an opportunity to stage their own programmes. The Swarovski Crystal Worlds, which are continually metamorphosing, are conceived as a 'serialised fairy tale' in which the toilets play a very special role. A spacious washroom, kept in legendary Ives Klein blue, opens onto a rotunda containing the toilets. The women's toilets are a fiery red, whilst the men's are cast in dreamy blue glass mosaic. At the centre, there is a black structure with a walnut-veneered counter for the washbasins, and a toilet for disabled people. All of the sanitary appliances are made of sparkling stainless steel; their intense glow competes with the light emanating from the ceiling spots.

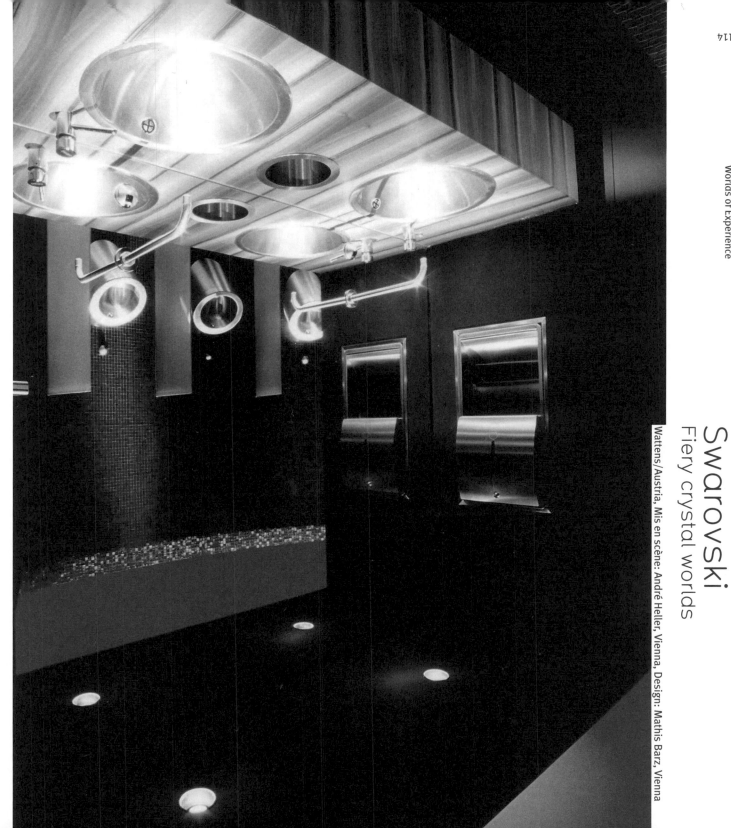

Swarovski
Fiery crystal worlds

Wattens/Austria, Mis en scène: André Heller, Vienna, Design: Mathis Barz, Vienna

Worlds of Experience

Toilet Museum in Seoul/ South Korea

Another toilet museum is located in Ilsan, outside the South Korean city of Seoul. The Goyang Exhibition Hall for Sanitation traces the history of toilets from Roman stone receptacles to medieval chamber pots to Japan's latest high-tech gadgets. In addition to showing a variety of traditional toilets and outhouses that reflect Korea's formerly poor agricultural society, the museum provides information on the ghosts and gods associated with toilet use. Numerous objects, accounts by elderly occupants, as well as photographs and films, paint a vivid picture of toilet history.

Money don't stink

'Pecunia non olet' (money doesn't smell) was what Emperor Vespasian's (69-79 AD) replied to his son Titus and his counselors, when they tried to talk him out of levying a tax on public latrines and urinals. He also planned to collect the urine in large containers and sell it to cloth dyers. Vespasian knew all too well that when they were most desperate, the population would gladly fill the state coffers. He sorely needed the revenue after the city had run out of money for the reconstruction of the Colosseum.

Toilet advertising

Advertisers dream of 20 to 48 seconds of undivided attention, during which consumers neither look away nor turn the page. This is possible in the toilet. Whereas toilet advertising has long been a fact of life in America and England, it is less common in Germany. Hung at eye level in front of the toilet bowl or the urinal, toilet ads can be studied at length in a relaxing atmosphere. The target groups are addressed differently, with technology predominating in the men's room and lifestyle themes in the women's.

This colourfully painted toilet is Dürrenmatt's 'Sistine Chapel'.

'Sistine Chapel' by Dürrenmatt

Friedrich Dürrenmatt (1921-1990) was a Swiss playwright, author and painter. 'Dürrenmatt loved to paint the rooms where he lived - no matter how long or short his stay. The first example is his student's garret in Bern, whose walls he painted with large colourful murals depicting mythological, religious, biographical and contemporary motifs. Dürrenmatt also left his mark on his home in Neuchâtel, where he decorated the toilet with brightly coloured, grotesque faces. Today this playful fresco can be seen in the exhibition rooms in the Centre Dürrenmatt.'
www.cdn.ch – Centre Dürrenmatt in Neuchâtel/ Switzerland

'Aquarius' washstand from the Xinox line

The 'Aquarius' is a free-standing, stainless steel washstand with a glass shelf, the illuminated mirror 'Atlas' and an integrated hand-towel dispenser. It is specially designed for doctors' surgeries, offices and semi-public institutions. It is part of Franke's Xinox line, which includes WCs, washstands, urinal walls, mirrors, shelves and clothes hooks – fifty-eight products in all.
Design: Berger + Stohl, Basel

Unisex toilets in 'Ally McBeal', 1990s

'Ally McBeal' (Calista Flockhart), the cult series about the tempestuous lives of American lawyers, was one of the most popular TV series of the 1990s. Its creators gave unisex toilets a prominent role. John (Peter MacNicol) spends about eighty percent of his working day in front of the mirror in the unisex lavatory, where he can sing and dance undisturbed with his idol Barry White. His partner, Richard, says: 'Unisex toilets create a sense of intimacy between male and female employees. That doesn't mean you go there to father a child!' Ally's fantasies are sometimes of a more violent nature and include fire-spewing female associates, lovers pierced by darts, and a deeply humiliated Ally, who for the umpteenth time jumps from the twentieth floor in response to an especially compromising situation. At her wits' end, Ally concludes: 'I'm normal. Not my life!'

Toilet paper

In ages past people cleaned themselves with the things that nature provided. Eskimos used tundra moss in summer and snow in winter. Seaside dwellers scraped their behinds with shells and coconut skins. The Chinese had paper as early as the sixth century, the denizens of the Middle East preferred water, Germanic tribes straw and leaves. Americans used corn husks and linen. In Ancient Rome, a sponge on the end of a stick was dipped into salt water for the same purpose (and is the origin of the expression 'to get the wrong end of the stick'). Archaeological evidence in castle and patrician house cesspools attests to the use of oakum, sheep's wool, hemp and (frequently) rags. Toilet paper was first introduced in the seventeenth century. After the storming of the Bastille, the opinion of the masses could be found in print in the loo. In 1857 Joseph Cayetty developed odour-absorbent scented toilet paper in the USA. The Swabian banker Hans Klenk, who founded the Hakle company, marketed the first 1000-sheet roll of coarse crepe paper in 1928, but it was not until the 1950s that the first tissue paper was available. Well into the 1970s, people cut newspapers into small strips and hung these from a string on a nail. In a number of countries it was common to eat with the right hand and wipe with the left. This is probably the origin of shaking with the right hand when greeting someone.

Toilet paper and paper boxes from the mid-nineteenth century

Inside the 'Empress' in the 'Tarot Garden'

Collaborating with her husband, Jean Tinguely, and drawing inspiration from Parc Güell by Gaudi, French artist Niki de Saint Phalle (1930-2002), who received international acclaim for her 'Nanas', created her masterpiece 'Giardino dei Tarocchi' over the course of fifteen years. In this magical garden, the twenty-two main tarot cards have been translated into huge, colourful sculptures that stand amidst olive and cork trees. 'I wanted to create a small piece of Paradise, an encounter between mankind and nature. (...) I set up house inside the 'Empress' card. I lived and slept inside the mother.' The Empress also contains a white reflecting toilet.

www.nikidesaintphalle.com – Il Giardino dei Tarocchi, Capalbio/Italien

WC in the 'Empress' in the 'Tarot Garden'

'Lady P' – the women's urinal by Sphinx

'Lady P' looks and functions like a men's urinal, but it is smaller and much more compact. Its shape has been specially modified for the female anatomy to meet the needs of women who prefer not to sit on public toilets. Women assume a skiing position over the urinal. Yet 'Lady P' is not just a urinal – it is part of a comprehensive concept that seeks to create privacy by incorporating specifically female elements: the urinal, a semitransparent glass partition wall, and a multifunctional container in which there is ample space for a sanitary bin, a shelf for handbags and a clothing hook.

Design: Marian Loth, Maastricht

'Twenty-five Hours', a film by Spike Lee 2002 – Ground Zero as a metaphor

We see him sitting on the toilet, facing the mirror. Suddenly, he can't restrain himself any longer: 'Fuck you!' He keeps on repeating the curse, declaiming the same four-letter word. And they all get their comeuppance: the whites, the blacks, the Jews, the Moslems, the gays, and even the taxi-drivers: "Fuck this whole city". An outburst of rage, a declaration of love – all in one. The fact is that Monty (Edward Norton) only has twenty-four hours left before he (a dealer) will be put in prison, and he is going to desperately miss every single thing he is cursing. Ground Zero, where New York's Twin Towers came crashing down, is the most appropriate symbol for his situation: as a metaphor for the ruins of his own life, as a symbol of emptiness and fear – not only his own, but of the entire nation.

The press spoke of a glass zeppelin and an extraterrestrial spaceship. And the new building – with its vaulted glass architecture and open plan – which the British telecommunications company commissioned for construction next to Hillmead Lake, certainly caused quite a stir.

Guided by the assumption that an outstanding building can influence a company's success, the architects decided to give the (mostly young) staff, who work in a rapidly growing sector, an office building that would be a pleasure to work in and would also foster communication. The idea behind the design was: 'If the staff feel at home they'll also be friendly to the customers'. The stairs inside the building are reminiscent of dinosaur skeletons, there are tea trolleys with a real-life tea servant, the curved reception desk is a combined juice and cappuccino bar, and each toilet is designed differently. One lavatory is made of stainless steel, with a transparent Plexiglas ceiling and mobile phones fitted into the toilet units.

The men's toilets there have wave-shaped washbasins, whilst the urinals are mounted in front of large mirrored walls. In another washing area the 'swimming pool', the walls and all the built-in elements are curved and finished in small mosaic tiles, whilst a fourth variation displays remarkable greenish-blue glass walls, glass washbasins and WC seats that are illuminated from below.

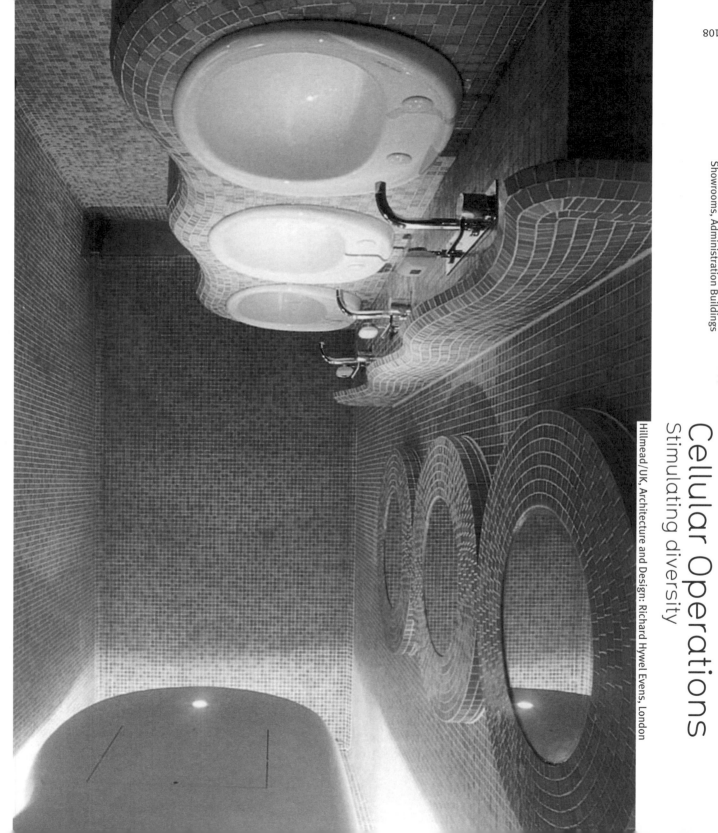

Cellular Operations
Stimulating diversity

Hillmead/UK, Architecture and Design: Richard Hywel Evens, London

Umdasch Shop Concept is one of
Europe's largest store designers. Its services range
from strategy and concept consultation to inde-
pendent retailing design, project management and
turnkey projects completed on site. In its administra-
tion building in Amstetten, even the toilets, which
feature the company colours of red and light grey,
have been designed to meet the company's high
standards. In a move that ironically abandons any
claim to prestigious appearance, the room-high mir-
rors have been mounted on two opposite walls in
the washing areas in an unbounded display of van-
ity. Stainless steel, glass and red Plexiglas vividly
communicate the company's colours. The urinal
area strikingly conveys corporate identity: profiles
of heads presented in different positions and sug-
gesting the physiology of former board members
are illustrated on the side partition walls. Even the
'smallest room' can evidently be used to transport
corporate identity.

Umdasch Shop Concept
Getting the image across

Amstetten/Austria, Design: Erich Sammer, Vienna

When jeans manufacturer Levi Strauss decided to have a new distribution centre built in Germany, the company needed an architectural approach that communicated diverse brand values combining tradition and reliability with a modern and casual look. The architects translated these values into a functional building that conveys clarity and open-mindedness, and matches the colour of the jeans. And even when the designers were planning the spaciously designed WCs, which are used by visitors and employees alike, they incorporated certain elements of corporate identity. The central core comprises a round urinal area whose trowel-finished walls – both inside and out – make use of the distinct blue of Levi's jeans. The granite shelves, the stainless steel washbasins and the rear walls in the urinal area underscore the functionality and clearly defined orientation of this modern company. At the same time, the subtle use of light gives the urinal area an almost private atmosphere. It is remarkable to see how designers can put across a company's image even through toilet design.

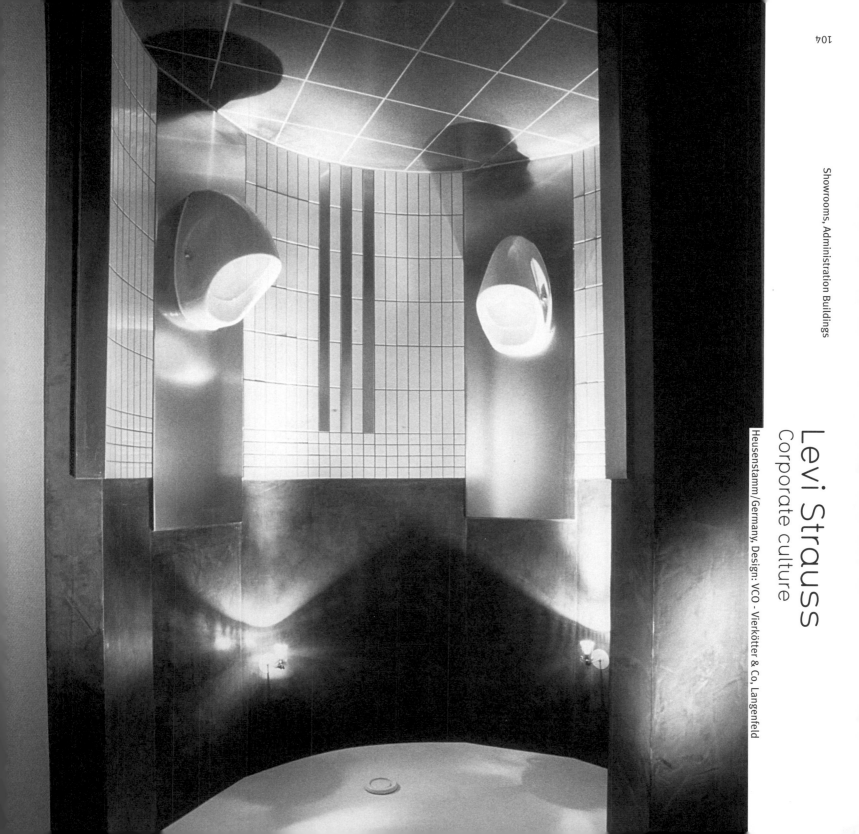

Levi Strauss
Corporate culture

Heusenstamm/Germany, Design: VCO - Vierkötter & Co, Langenfeld

The showroom, embodying the new image Nissan wants to convey, is supposed to communicate openness, clarity and, above all, the profile that is increasingly shaping the company's new product strategy, with independent vehicle models designed to boost Nissan's brand image. Included in this campaign, the showroom toilets have been designed to impress visitors and demonstrate to them that this area is just as important to Nissan as the world of motor vehicles. Hence, the toilets can be seen gleaming from afar, making them look almost more splendid than the showroom itself. The same materials have been used throughout: artificial white marble, large mirrors, abundant indirect light, and back-lit glass areas. The visitor to the toilets is struck by their unusual, beautifully formed acrylic washbasins, whose design has more to do with the aerodynamics of vehicles than with the forms generally used for sinks. The back-lit mirror walls in the trapezoidal urinal area are decorated with etched stripes. The stainless steel urinals, designed by Philippe Starck, make this a memorable ambience.

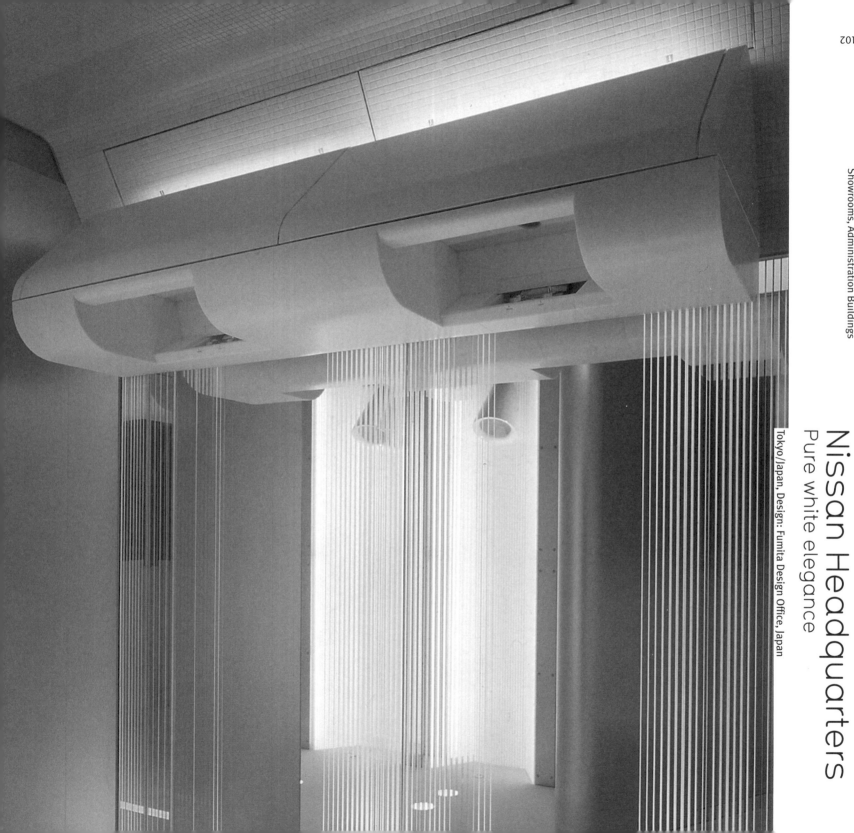

Nissan Headquarters
Pure white elegance

Tokyo/Japan, Design: Fumita Design Office, Japan

The Berlin showroom not only displays the various uses to which Bisazza products can be put, but also provides a setting for art, architecture and design events. The architect was inspired by Samuel Beckett's Waiting for Godot. Two impressive eyes in the shop window direct visitors' attention to a large antique mask inside the room; its gold mosaic interior and steel exterior reflect the eternal interplay of appearances and reality, theatre and life, mind and matter. Standing behind the mask, visitors can look out through it and experience the world in new ways. The final scenes of Godot's play, depicted in mosaic, decorate the stairs leading down to the basement lounge: a symbol of eternal waiting; an image of and a metaphor for Berlin.

The toilets, contrasting with the showroom, are characterised not by mythological elements but by the element of water. Mosaic strips in autumn hues describe circles around the wash-basins and toilets and run across the walls, calling to mind the rings radiating outward like ripples from a drop of water landing in a pond. Thus employed, the mosaic creates a sense of constant flow, of movement and rotation – and is a symbol of change.

Bisazza in Berlin
Reality and appearances

Berlin/Germany, Architecture: Fabio Novembre, Milan

The setting is a former city palace owned by the Vicomtesse de Noailles, an artist and patroness who supported painters and poets such as Weill, Dalí and Buñuel from 1920 on. It was here – not far from the Arc de Triumph – that Baccarat, the French glass manufacturer, constructed a magical crystal palace with a boutique, museum gallery, reception hall and restaurant. 'The interplay of light and glass inspired poetic games (...), it was a world of illusion and magic,' Starck tells us. At the entrance, an eternal flame flickers in reflecting glass fireplaces, an ostentatious chandelier is sunk into an aquarium, and a 2.5-metre-high chair with reflecting legs conjures up images of Alice's Wonderland. A restaurant, the Crystal Room, now occupies what was once the Vicomtesse's dining room. In addition to Starck's fantasy furniture, it features high ceilings, frescoes and chandeliers, fireplaces and examples of precious woodwork. Naked brickwork contrasts with golden stucco. And the restaurant's toilets even call to mind a hall of mirrors. Here, crystal chandeliers illuminate room-high reflecting walls with orange-red glass surfaces. As if guided by an invisible hand, water runs from the pipe into chrome-plated water basins on glass washstands.

Baccarat Kristallmanufaktur
Hall of mirrors

Paris/France, Design: Philippe Starck, Paris

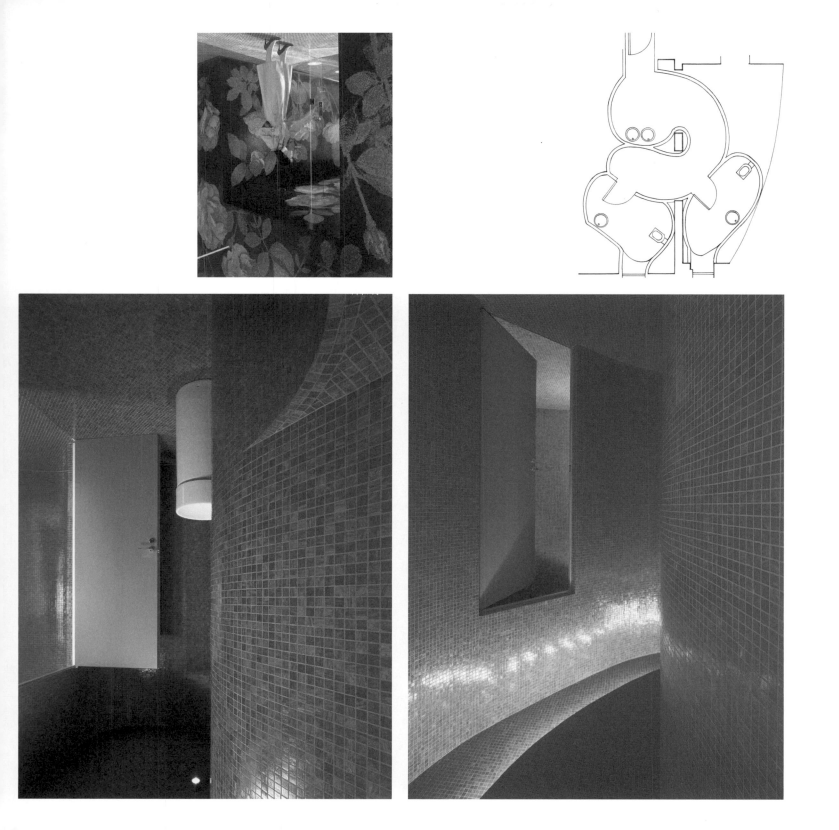

When the architect designed the showroom for the Alte headquarters of Bizazza, the manufacturer of mosaic products, he used perspective to sensitise visitors to the novel uses of Bizazza's materials. He explored these uses rather poetically in this design by placing Victorian-style roses at the entrance and constructing a reception area that resembles a garden vault. The washing areas and toilets are also spacious, and comprise rooms that take up the organic shapes of rose leaves and intertwined garden paths. The walls, ceilings and floors are covered in pink mosaic, setting off the white cylindrical wash basins and lending them the appearance of art objects. The glass surface accentuates the effects of the lighting, interacting with the informal light of the bulbs on the spiralling ceiling and blurring the boundaries of the room. From the spacious washing area, the visitor is led quite naturally to two large toilets, executed in blue and green, whose curved walls create an almost supernatural atmosphere.

Bisazza in Alte
Rose rooms

Alte/Italy, Architecture: Studio Carlo dal Bianco, Vicenza

Showrooms, Administration Buildings

Showrooms, Administration Buildings

Oh, toilet seat on the wall

The theme restaurant 'Planet Hollywood in Berlin' surprised washroom visitors by replacing its standard mirrors with gigantic toilets seats. And they didn't stop here – even the walls had screwball patterns of black tile.

Chamber Pot and Bourdalou Museums in Munich

The Centre for Unusual Museums in Munich contains two unique collections: the Chamber Pot Museum and the Bourdalou Museum.
www.zam-museum.de

'McDry' – the waterless urinal

Though shaped like a teardrop, this sanitary ceramic urinal does without water. The ceramic siphon is filled with a non-water soluble, biodegradable liquid and filters the urine, which flows directly into the sewage system. The urinal basin is cleaned with a special agent or, occasionally, with water. Acquisition, installation and operational costs are apparently much lower than those for traditional urinals.
Design: Duravit, Hornberg

'Taxi zum Klo', a film by Frank Ripploh, 1980

When this movie opened, its distributors advertised: 'Taxi zum Klo will make you want to be a man.' Shot on a budget of only 50,000 euros and without any grants, Frank Ripploh's film went on to attain cult status on the gay scene, taking in a million dollars in New York City alone. It also won the coveted Max Ophüls Award at the 1981 Saarbücken Festival. Ripploh does not see his work as gay cinematography. 'It's a sad movie that, despite all its comic moments, expresses both the longing for and the ultimate impossibility of love.' A product of the pre-AIDS 1980s, it is a liberating, honest embrace of a gay lifestyle, and today pays homage to a much different age.
From: Jacob Blume: Von Donnerbalken und innerer Einkehr. Göttingen 2002

Marcel Duchamp – 'Fontaine'

Surely the most famous toilet bowl art is the readymade entitled 'Fontaine' by the French artist Marcel Duchamp in 1917. Protesting art's hollow pathos, its loss of meaning, as well as its transformation into a commodity, he turned an ordinary white ceramic urinal upside down, signed it with the name of the sanitary company, and declared it an object of art.

From: Pierre Cabanne: Ducamp & Co. Paris 1997

Small toilet building in Munich, 1862

'Get Fresh' modular system solution

'Get Fresh' is the name of a modular system by Kuhfuss for public toilet construction, designed not only for semi-public companies and public institutions, but also for hotel chains, trade show companies, conference operators, department stores and sports facilities – wherever hygiene, well-being and freshness are crucial aspects of customer service. All the sanitary appliances are preinstalled on ready-to-connect wall elements and can be adapted to different spatial situations. The system comprises several modules: a WC cubicle with a bull's eye window, a washing area with a mirror, urinals, towel dispensers, as well as a column fountain that evokes the idea of freshness. All these elements are interchangeable and come in different materials and surfaces. The company also makes suggestions concerning floor coverings, walls, ceilings, lighting and water control.
Design: Sieger Design, Sassenberg

Public toilets in the nineteenth century

'Until the mid-nineteenth century, the Berlin Schauspielhaus theater contained a room where men could go to urinate. Each man was assigned a chamber pot on the wall. After he had filled it, he was expected to empty it in the large collective tub in the middle of the room.'
August Bebel: Aus meinem Leben. Bonn 1997

Au naturel in the Middles Ages

The Middle Ages stank to high heavens – it was as if people had completely forgotten the technique of using water in sanitary facilities. They did their business in public, over cesspits, on dunghills in the countryside, or in heart-style outhouses (with hearts cut into their doors). In cities they relieved themselves in the streets or against the walls of buildings. Private chamber pots were simply emptied out the window. In combination with the taboos on excrement and Church bans on washing, these practices encouraged the spread of diseases and epidemics. Even in medieval castles, occupants enjoyed, at best, primitive toilet facilities whose contents adorned castle walls. In many cities, the garderobe toilets projecting from outer castle walls continued to exist in the nineteenth and twentieth centuries.

Fifteenth-century outhouse between buildings

Bertold Brecht – 'Baal', 1918

Orge told me that:
In all the world the place he liked the best
Was not the grass mound where his loved ones rest
Was not the altar, nor some harlot's room
Nor yet the warm white comfort of the womb.
Ore thought the best place known to man
In this world was the lavatory pan.
That was a place to set the cheeks aglow
With stars above and excrement below.
A place of refuge where you had a right
To sit in private on your wedding night.
A place of truth, for there you must admit
You are a man; there's no concealing it.
A place of wisdom, where the gut turns out
To gird itself up for another bout.
Where you always doing good by stealth
Exerting tactful pressure for your health.
At that you realize how far you've gone:
Using the lavatory – to eat on.
Translated by Peter Tegel,
© 1970 by Methuen & Co Ltd

Bathroom Mania

Dutch illustrator-designer Meike van Schijndel believes it's high time we gave bathrooms and toilets a new character, designed them with more imagination, and moved beyond mere functionality. She hopes to achieve these goals with splashes of colour and products that are fun to use: 'Let your imagination soar: relax and drift off into the world of your dreams. Stimulation and relaxation are essential in today's hectic world.' 'Kisses' is a unique ceramic urinal that will 'give you reason to blush whenever you visit the loo.'
www.bathroom-mania.com

Johann Wolfgang von Goethe – 'Faust II', 1832

To us remains an earthly residue
painful to bear.
And though it were of asbestos,
yet it is not pure.

On journeys

Whereas Saxon kings hitched a wagon containing the royal close stool (an early toilet) to their coaches, most carriages were equipped with a discretely concealed hole that allowed passengers to answer nature's call during the ride. Otherwise, the driver would stop so that they could attend to their business in the great outdoors. The first trains had no sanitary facilities, a situation which, in Spain, persisted well into the twentieth century. Train station toilets consisted of two boards attached to a free-standing pole. On ships human waste went over the railing, in submarines through the torpedo chute, and on the first planes out into thin air.
From: Jacob Blume: Von Donnerbalken und innerer Einkehr. Göttingen 2002

A green getaway for two, far removed from the heat and bustle of the world – this building with its fanlike divisions and flat wall panels has been perfectly integrated into the surrounding rubber trees. Oriented to the directions of the compass, it boasts northern and southern decks projecting into the countryside, which is visible from every room. The bathrooms and toilets also have access to the great outdoors, and through their room-high glass doors occupants are treated to seductive views. The entire building is characterised by varying colours, materials and structures. Polished concrete floors and coloured, smooth plaster walls provide an ideal backdrop for the play of colours and light. Bathroom furniture made of Marblo – a translucent plastic – glows from within; indirect light seeps out from behind the mirror and emanates from the illuminated ceiling. The guest toilet has an especially appealing design. A low wedge-like cabinet runs diagonally out into the room, merging with a cylindrical wash basin. Everything is made of Marblo. Small downlights dramatically emphasise the wash basin and toilet, creating a three-dimensional still life. Due to the hot climate in Australia, the house has watering holes in every corner – even under the stairway, where the strip lighting makes the wash basin shimmer.

first

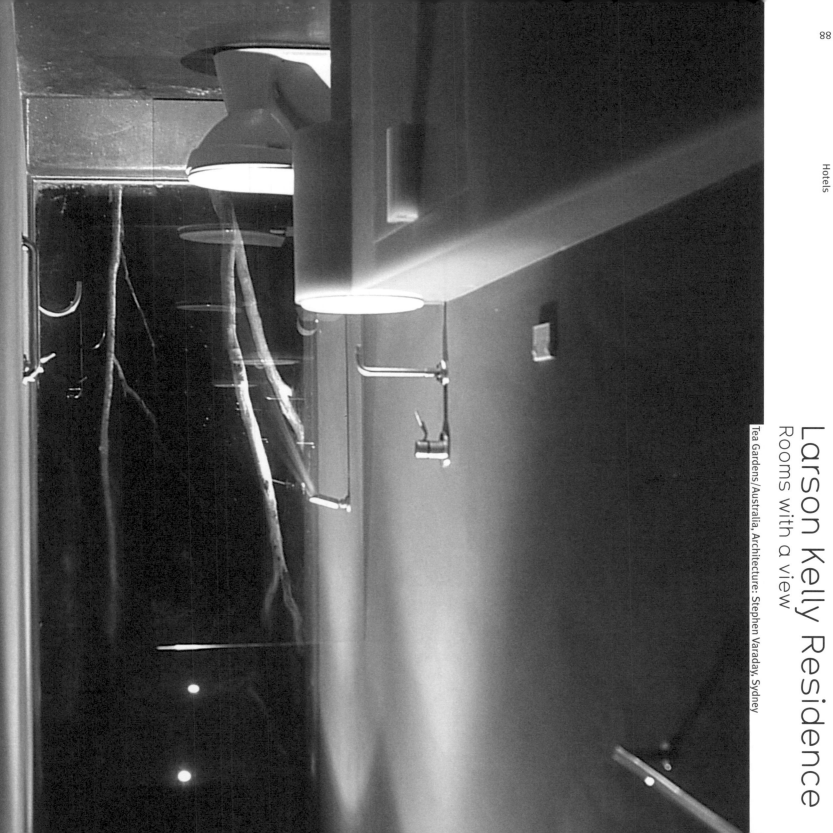

Larson Kelly Residence

Rooms with a view

Tea Gardens/Australia, Architecture: Stephen Varaday, Sydney

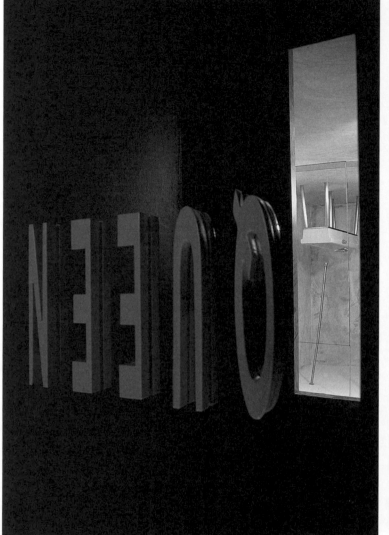

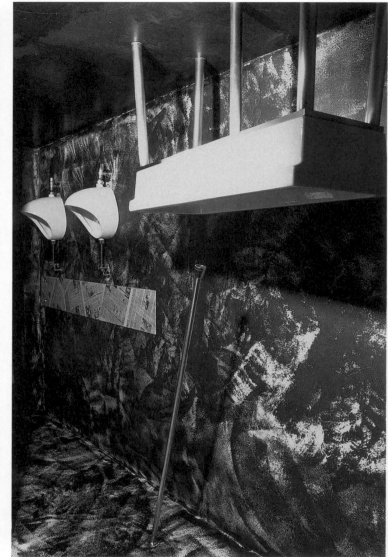

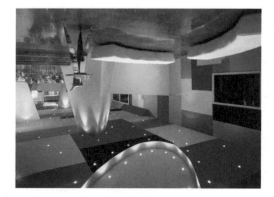

The Corte dei Butteri Hotel on the Tuscan coast has a classic Mediterranean exterior. Inside, it takes your breath away with its vivid palette of colours, which radiate from the floors, walls and ceiling. The room is covered in fields of yellow, green, red and black, which blur its borders. The lobby features large sofas and a blue synthetic-resin floor. The reception desk is clad in galvanized steel, and pop art chairs are grouped around conical pillars. For hotel guests, this experience of space is a cultural and communicative act that has assimilated the virtual

images of our time. There is less colour in the toilets, which bear the titles 'Queen' and 'King', but are otherwise twin spaces where only the surfaces differ. The floors are made of a poured synthetic resin that has been mixed with a white pigment in the lady's room and black in the men's. The walls and ceilings have swirling patterns, and the cubicles are concealed behind mirrored walls. The water runs into a large white ceramic trough via a narrow pipe from the ceiling; the remaining sanitary appliances are also white.

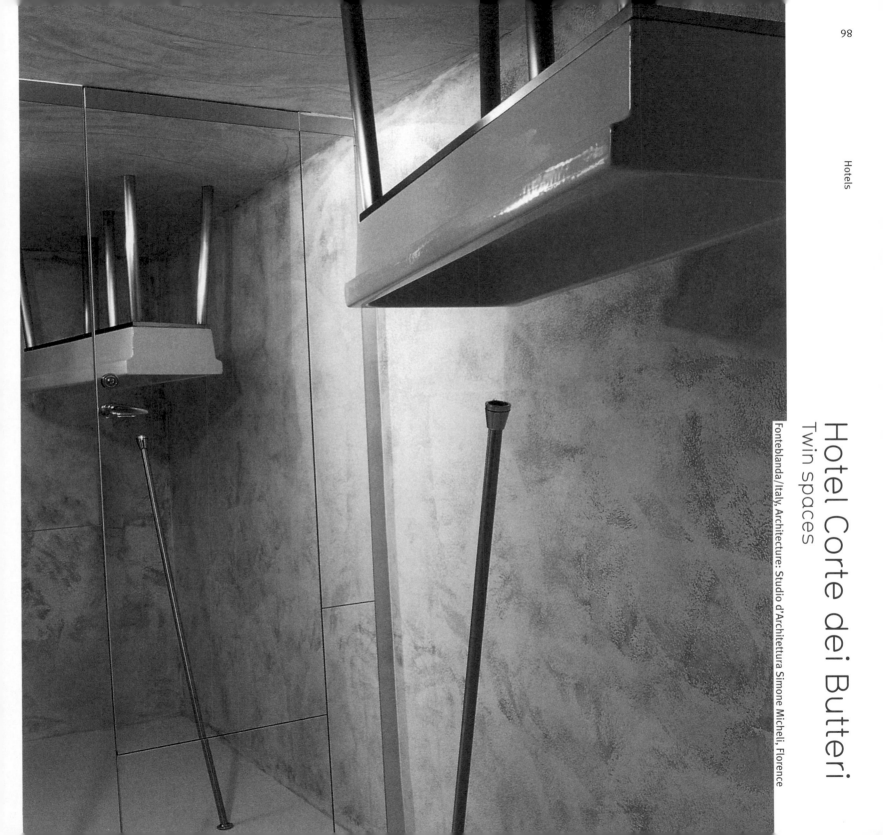

Hotel Corte dei Butteri
Twin spaces

Fonteblanda/Italy, Architecture: Studio d'Architettura Simone Micheli, Florence

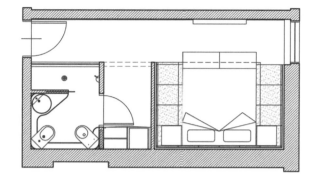

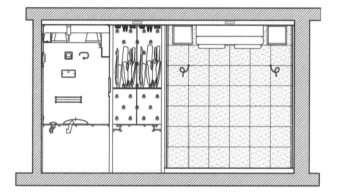

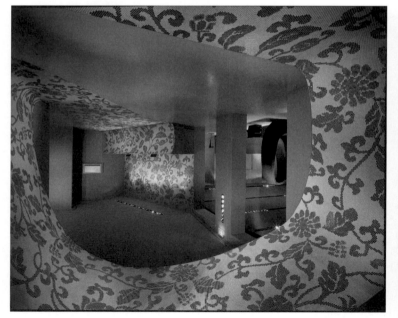

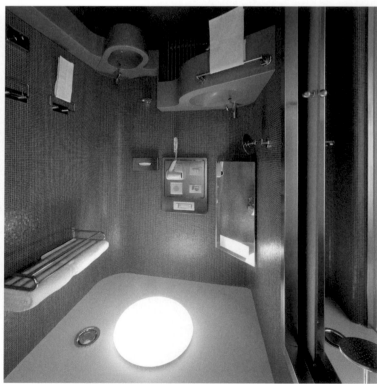

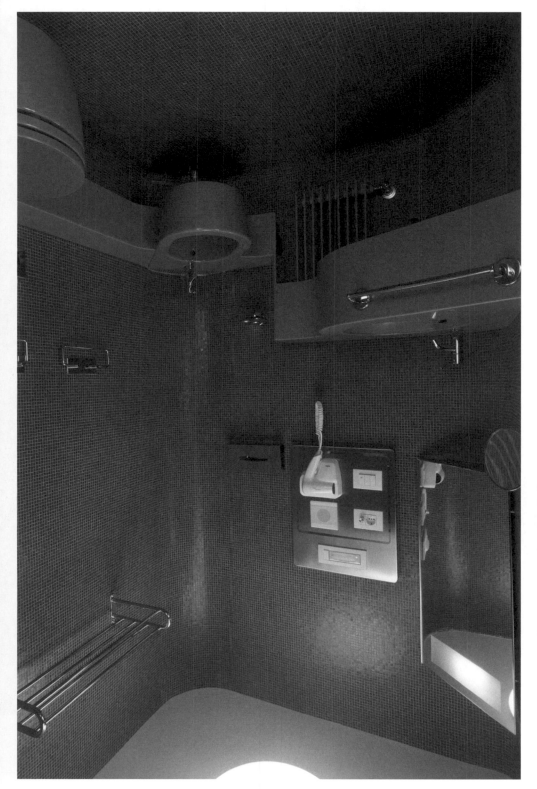

For architects, hotels are like trees: their broad branches reach out across the world, and their roots are firmly fixed in the soil. In Florence, home of the arts, the Una Hotel has found fertile soil indeed.
Located not far from the city centre in the historic district of San Frediano, it is both an inspiring stop-over and a home for guests with the most diverse lifestyles. A flowery carpet of glass mosaic tile spi-rals from the floor to the ceiling in the reception hall. Tall, red, padded helixes carve out conversational spaces in the lounge. The halls leading to the hotel rooms resemble those of an art gallery; gold-framed doors showcase eighteenth-century aristocrats – a homage to the Uffizi painting gallery in Florence. This hotel is a storied place for intellectual nomads who want to settle down briefly between flights. They can kick up their heels in the hotel's bathrooms and washing areas with their soft shapes and mosaic tiles – some immersed in white, others in blue. The bathtubs, sinks, bidets and toilets fit in organically. A restful oasis in the maelstrom of time.

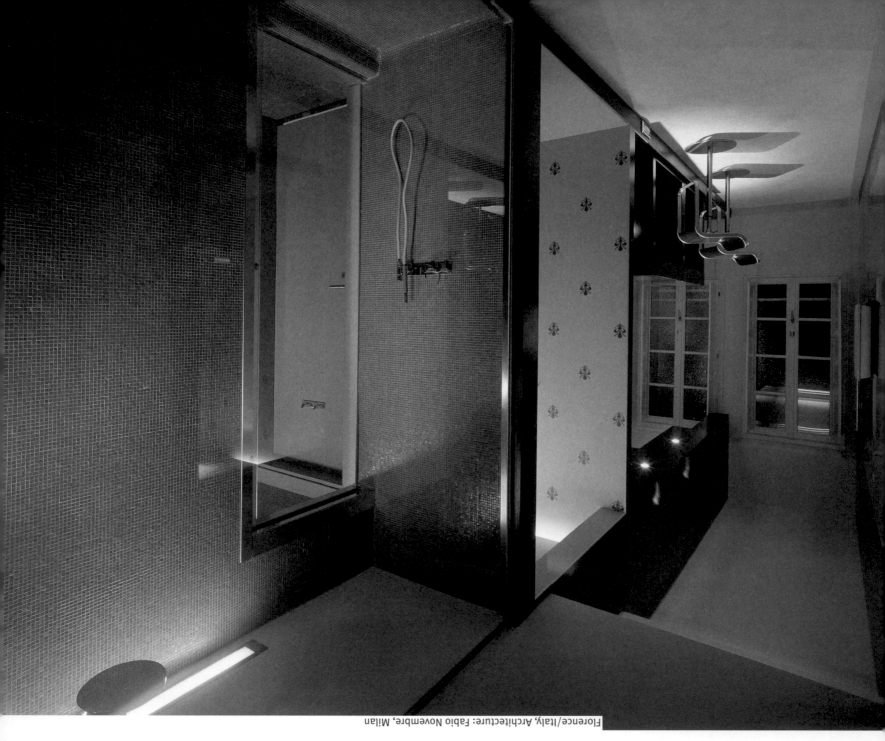

Florence/Italy, Architecture: Fabio Novembre, Milan

Hotel Una
A restful oasis in the maelstrom of time

The fashionable, stylish Aleph – a boutique hotel in the centre of Rome – is a provocative architectural interpretation of Dante's Divine Comedy. The contrasts between heaven and hell are illustrated throughout the building as part of the design concept. At the entrance, life-size samurai figures of painted wood draw attention to the eternal dichotomy between good and evil. In a surprising twist, Paradise is located in the cellar, in the pure whiteness of the wellness area with its Roman baths. Visitors succumb to endless temptations in the Dionysius Bar, the Sin Restaurant and the library – all are afire in a devilish red. The lavatories and washing areas further refine the concept. Inside and out they are covered with radiant red mosaic tile that is highlighted by horizontal strips of black granite. A neat contrast is provided by the chilly stainless steel of the fittings, frames and sanitary appliances (concealed behind matte glass sliding doors). Glass sinks and the nearly two-metre-long glass trough in the washing area intensify the hotel's almost mystical character. The few ceiling spots make this room a stimulating experience. 'A hotel is not only a place to stay but a state of mind,' muses Tihany, the designer, philosophically.

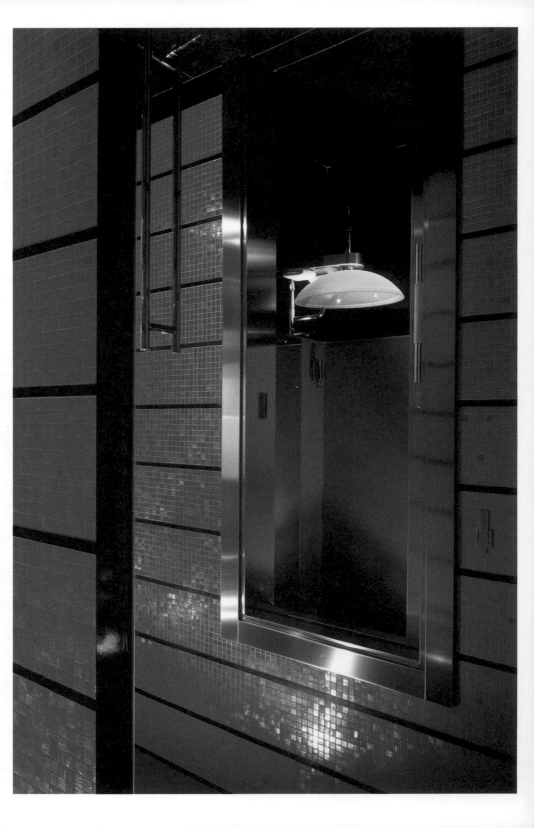

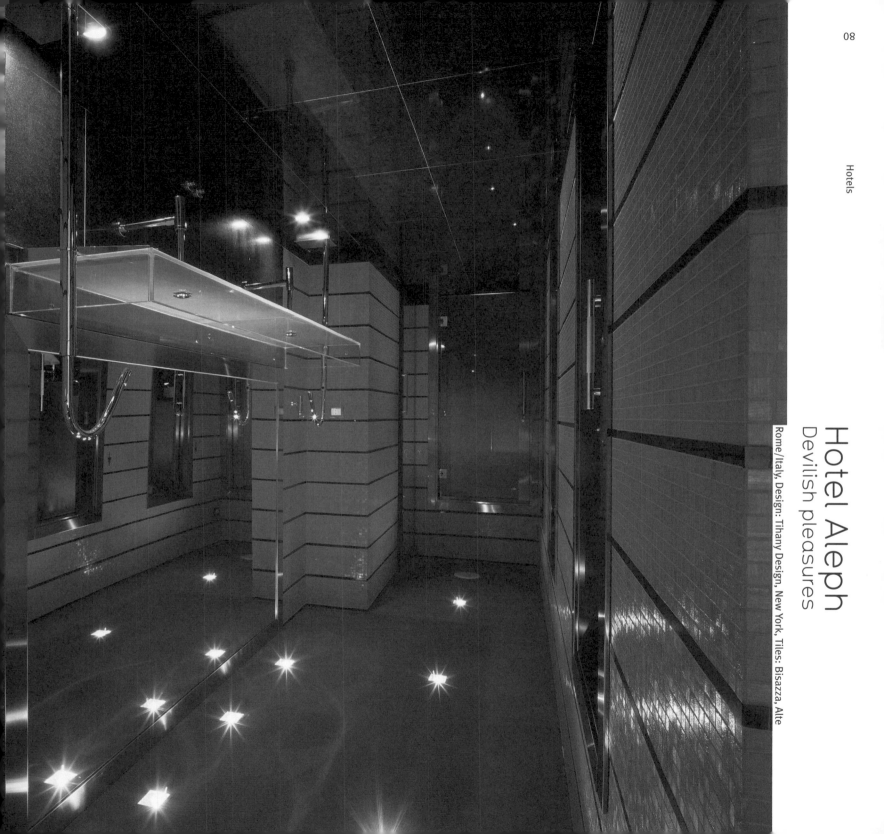

Hotel Aleph
Devilish pleasures
Rome/Italy, Design: Tihany Design, New York, Tiles: Bisazza, Alte

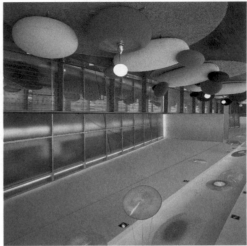

The Side Hotel, which is located in the centre of Hamburg, combines minimalist elegance and spectacular lighting for a modern, cosmopolitan clientele desiring both comfort and an intimate atmosphere. The centrepiece of the building is a 24-metre-high glass atrium whose design captures the flair of the city without the 'obsessive kitsch' of large grand hotels. 'Less is comfortable' is the motto here, even in the public areas down in the basement, where hall-sized men's and women's rooms await restaurant guests and concert visitors.

Ladies relax in a sea of pink, while men are refreshed by luminous blue. The oval shape of the rooms, together with the artistically designed ceiling lighting, intensifies the effect of this colourful 'wrapping'. The entire interior – from the round sinks and the purling glass urinal wall to the leather stools in front of a large mirrored niche – are rendered in one colour. These rooms stimulate the senses with their materials, lighting, warmth, vitreous transparency and fragrances.

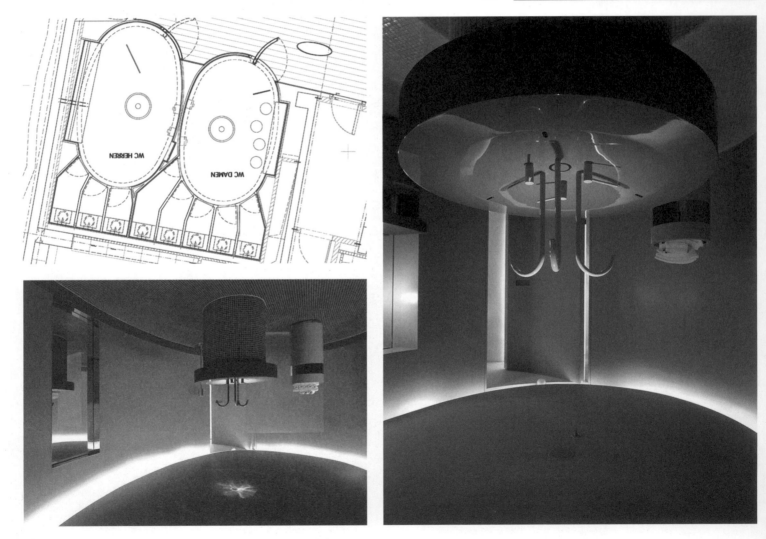

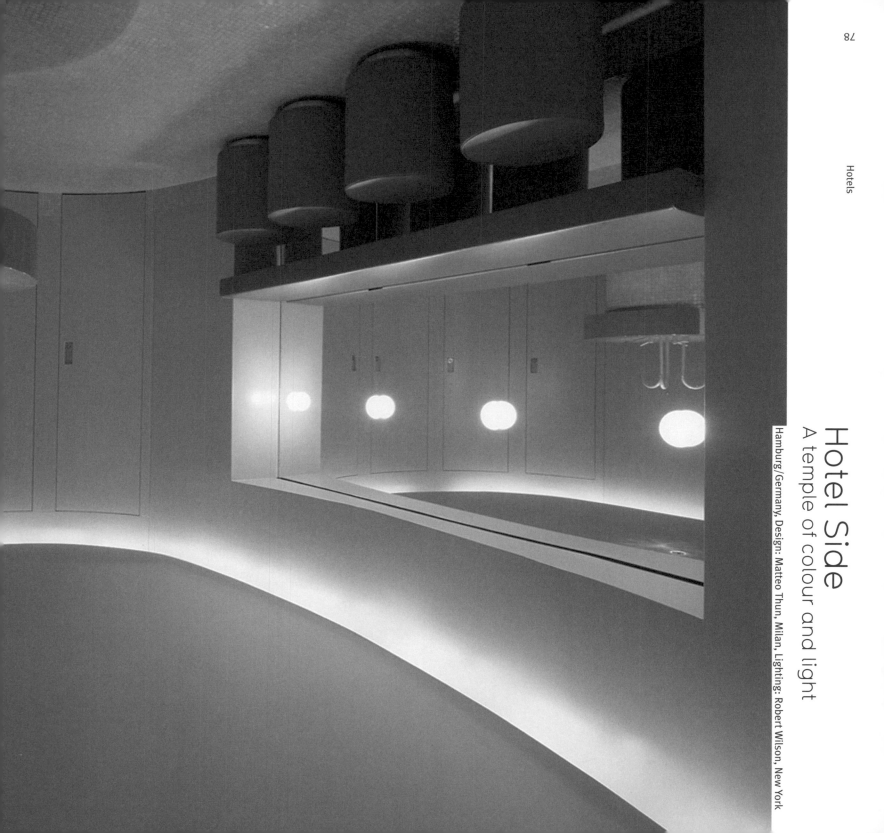

Hotel Side
A temple of colour and light

Hamburg/Germany, Design: Matteo Thun, Milan, Lighting: Robert Wilson, New York

Hotels

Screen advertising on urinals

The English 'Viewrinal' is a contemporary example of monitor advertising on a urinal. It resembles a white plastic switch-box with an eyelevel screen. The monitor, which is connected to the Internet, is designed for displaying advertisements, promotional material and for providing information. It can also be used to show videos with full surround sound. The tub-shaped urinal is contained in the lower part of the box. Sensors register the number of visitors, providing ideal feedback for the advertising companies that supply the material. The 'Viewrinal' is primarily intended for trendy nightclubs and bars and is specifically aimed at a target group of eighteen to thirty-five-year-olds. It made its first appearance in the Aquarium Nightclub in London. Customers advertising with it include Virgin Interactive and 20th Century Fox. Incidentally, for the ladies there are 'Viewloos', which are set up in the toilet washing area to make the waiting more pleasant.

Design: Captive View/EMJ Plastics

Sulabh International
Museum of Toilets in
New Delhi/India

The museum was established by Dr. Bindeshwar Pathak, the founder of an NGO within the health sector. It contains a rare collection of objects and images showing the development of toilets from 2,500 BC to the present. In addition to the exhibits, it also provides information on technologies, social customs, sanitary conditions and legal provisions. Exhibits include chamber pots, commodes, toilet furniture, bidets and water closets as well as beautiful poems on the subject of toilets.

www.sulabhtoiletmuseum.org

LED seat

Even at its trade fair debut, the 'Galaktika LED' toilet seat was a smash hit. It shines so brightly that it can light up a fully fitted-out 15-square-metre bathroom. The secret lies in its sophisticated electronics. The inside of the WC seat is filled with tiny, ultra-bright LED chips in five different colours: polar white, sundance yellow, amparo blue, scarlet red and emerald green. Power is supplied by three AA 1.5 V batteries attached either to the back of the toilet basin or the underside of the cistern. When the lid is raised, the LEDs begin to glow, reaching full luminosity within five minutes. When the lid is closed, the light diodes gradually fade out.

www.kiss-textil.de

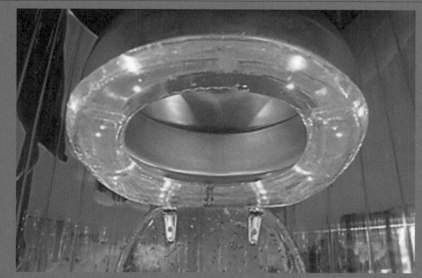

Macbos und Hembras in Lanzarote

César Manrique (1919–1992) is considered by many to be one of Spain's most important artists. With his buildings, which he designed to correspond with their natural surroundings, César Manrique sought to preserve the beauty of his home island, Lanzarote. His architecture embodies his central idea: to achieve a synthesis of art and nature. Whether on the island's vantage points or in the Fundacion (his former house, built from large lava bubbles), the witty entranceway pictogrammes and island views make his architecture and objects of art, not to mention his toilets, well worth seeing.

www.fcmanrique.org – Fundación Manrique in Arrecife/Lanzarote

Milan Kundera – 'The Unbearable Lightness of Being', 1984.

'Toilets in modern water closets rise up from the floor like white water lilies. The architect does all he can to make the body forget how paltry it is, and to make man ignore what happens to his intestinal wastes after the water from the tank flushes them down the drain. Even though the sewer pipelines reach far into our houses with their tentacles, they are carefully hidden from view, and we are happily ignorant of the invisible Venice of shit underlying our bathrooms, bedrooms, dance halls, and parliaments. The bathrooms of the old working-class flats on the outskirts of Prague were less hypocritical: the floor was covered with gray tile and the toilet rising up from it was broad, squat and pitiful. It did not look like a white water lily; it looked like what it was: the enlarged end of a sewer pipe. And since it lacked even a wooden seat, Tereza had to perch on the cold enamel rim.'

English translation © 1984 by Harper & Row, Publishers, Inc.

'City Toilette' incl. advertising

The 'City Toilette' is a free-standing, self-contained building that is automatically cleaned each time it is used. It has been designed for large cities and is offered to municipalities free of charge. Companies like Wall in Berlin manufacture, install, maintain and clean the 'City Toilette', and obtain their revenue by renting out advertising space. The elliptical structure (designed by architects such Citterio, Ion, and Kleihues + Kleihues) comes in a number of variations so that the toilet can be adapted to existing urban architecture. Illuminated advertisements indicate the WC's location. The fixtures are suitable for men, women, wheelchair users, blind people and parents with baby carriages.